THE ESSENTIAL STUDENT GUIDE TO PROFESSIONAL PHOTOGRAPHY

GRANT SCOTT

Focal Press
Taylor & Francis Group

NEW YORK AND LONDON

First published 2016
by Focal Press
70 Blanchard Road, Suite 402, Burlington, MA 01803

and by Focal Press
2 Park Square, Milton Park, Abingdon, Oxon OX14 4RN

Focal Press is an imprint of the Taylor & Francis Group, an informa business

Library of Congress Cataloging in Publication Data
Scott, Grant.
The essential student guide to professional photography / by Grant Scott.
pages cm
1. Photography--Vocational guidance. I. Title.
TR154.S285 2015
770.23--dc23
2014041555

ISBN: 978-1-138-80532-3 (pbk)
ISBN: 978-1-138-80531-6 (hbk)
ISBN: 978-1-315-75243-3 (ebk)

Typeset in Akzidenz Grotesk and Franklin Gothic by Servis Filmsetting Ltd, Stockport Cheshire

Printed and bound in India by Replika Press Pvt. Ltd.

For Samantha, Alice, Daisy and Florence.

CONTENTS

P 88 **CHAPTER 5**

GOING IT ALONE, AND WHERE DO YOU FIT?

WHAT IS PROFESSIONAL PHOTOGRAPHY?

WHEN THE WORD 'PROFESSIONAL' is used in conjunction with the creation of photographs it is most often seen as a comment on the technical quality of an image. Camera manufacturers describe the most expensive cameras they produce as being for professionals and others as providing professional-quality images. They believe that we all want to be able to create professional images. But before we begin to discuss the role of the professional photographer we must first talk about what defines a professional photograph. What are considered to be professional images, and are they really professional?

Let's deal with what elements are most commonly believed to constitute a professional image. The basic requirements are:

- **Is the picture in focus?**
- **Is the lighting correct for the subject? Not too dark or too light.**
- **Is the photograph well composed?**
- **Is the subject in the center of the frame?**
- **Has the background been considered?**
- **Has it been softened by the use of depth of field?**

In short, has the photographer been able to control a series of technical aspects and aesthetic judgments to create what is considered by many to be an 'acceptable' image? Camera manufacturers create cameras that make all of these judgments as easy as possible to make correctly and present automatic options for everything except the composition of the image. They do everything they can to help you create a 'perfect' image, but are these images professional? Well no! Professional photography is not based purely on creating 'perfect images' or mastering technical processes and techniques. Although this is definitely not a manual on how to take better photographs, it is important to have an understanding of the basic rules of photography to ensure that you are in control of creating your images. To that end your first step to working professionally is to stop using the automatic functions on your camera (except focusing, but even then you should not rely completely on the automatic function)

and to concentrate on the composition of the image you want to create and the subject matter of that image. This is the beginning of creating images that are personal to you and the development of your own visual language and a step toward creating professional photographic images.

Anybody can be a great photographer if they zoom in enough on what they love.
Photographer: David Bailey

CREATING A VISUAL LANGUAGE

In 2014 alone 2.25 billion picture-taking devices were sold globally, with smart phones making up more than half of that total. In 2013 89 million digital cameras were sold—only 4 percent of the global sales of devices that take pictures. With that many people taking photographs with 'nonprofessional' equipment, it is essential that professional photographers can give their clients a reason to pay for their images. This reason will not be based purely on the mastery of technical skills, as this is something that many people can achieve. It will be based on the photographer's ability to capture how he or she sees the world and persuade people who need photography within their business to react positively to the photographer's way of seeing. Professional photography is a business that interacts with myriad other businesses, and it is that interaction that I hope to help you understand.

Billions of photos are shot every year, and about the toughest thing a photographer can do is invent an original, deeply personal, instantly recognizable visual style.
Art Critic, *New York Magazine*: Jerry Saltz

Photography has been a business since its creation, but its professional application was initially limited to the wealthy and those comfortable with its chemical requirements. However, the use of photography as a means of education goes back to its earliest days in the mid to late nineteenth century, when travel photography bought images of the world to those who could not afford to travel. This soon progressed to the documentation of wars and battles that filled the newspapers hungry to bring the new medium of photography to their news reporting and readers eager to see images direct from the battlefields of the American Civil War, and the Crimea and the Boer Wars. On the home front every high street contained a portrait photographer happy to document families, children and those wishing to have their portrait taken for the creation of a *Carte d'Visite* (a photographic calling/business card).

Two examples of nineteenth-century *Carte d'Visite*, one of the earliest forms of commercial portrait photography.

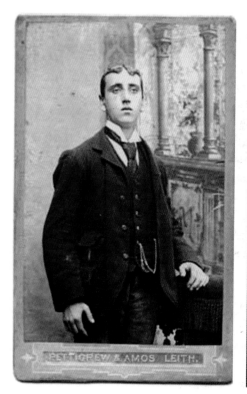

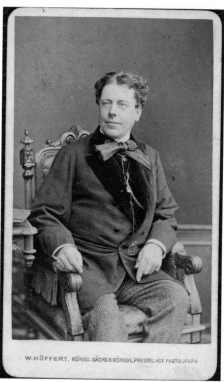

LIFE and *Picture Post* magazines were both published weekly and promoted quality photography and the importance of the photographic story. Both recorded high sales that were greatly diminished by the advent of television.

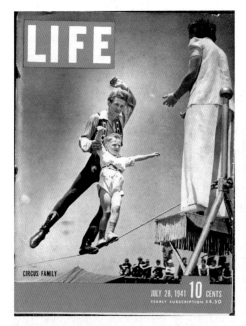
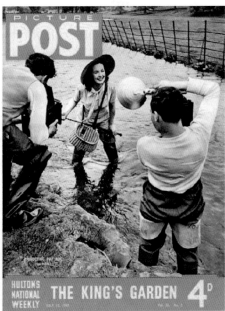

I wish more people felt that photography was an adventure the same as life itself and felt that their individual feelings were worth expressing. To me, that makes photography more exciting.

Photographer: Harry Callahan

PROFESSIONAL PHOTOGRAPHY IS A BUSINESS

It was not until the beginning of the twentieth century, however, that the power of the photographic image became obvious to those wanting to sell products through advertising and magazines. The

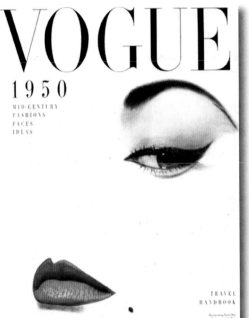

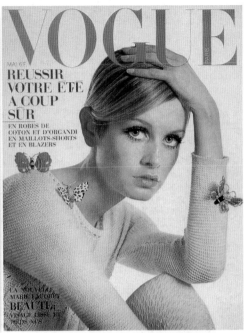

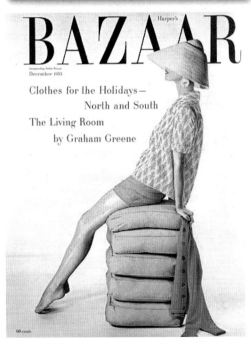

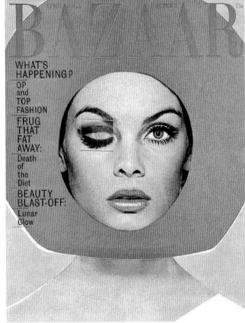

Fashion magazines were an important showcase for professional photographers throughout the twentieth century, as they gave creative freedom to photographers shooting fashion, portraiture, food, interiors and social documentary images.

A graphic image taken from a fashion narrative shot by Ben Breading.

illustrated magazine was the most important vehicle for the growth and development of professional photography throughout the last century, providing a home for all genres of photography and in turn creating a professional model for the commissioning of photography from professional photographers. Weekly photo magazines such as *LIFE* and *Picture Post* brought the news, issues, everyday events and wonders of the world to every home until the global domination of television in the Sixties, while fashion magazines such as *Vogue* and *Harper's Bazaar* pushed the boundaries of what was acceptable in both fashion photography and magazine design throughout the century.

*French Vogue **was always a photographer's magazine.***

Former Editor-in-Chief, *French Vogue*: Carine Roitfield

The Sixties saw the demise of the weekly photo magazine and the rise of the weekly newspaper supplement. Photography had found a new home and a new champion as the competition between newspapers became ever tougher and each strived to publish bigger and better supplements filled with the best photography and photographers' work they could find. Professional photography was on a high and enjoying a golden period both creatively and financially. Brands saw the benefit of investing in photography to create ever more innovative advertising campaigns, and magazines with high readership circulations were the perfect environment from which to sell products. But as with all golden ages the end was inevitable, and as photography approached the conclusion of the twentieth century international global economic downturns started to have a direct impact on the advertising and publishing industries. The world of professional photography felt that impact hard, but just as it started to re-establish itself within the realities of a new economic climate the greatest change to how photographs were created and seen in over a hundred years took place.

The digital revolution saw the world of professional photography turned on its head, and we still haven't stopped turning. This wasn't just a photographic revolution but also a global communications revolution that has forced professional photographers to completely reassess their profession and their roles within it. For the established photographer this has required a willingness to be open to new ways of working, seeing and engaging with clients. For the young photographer just starting out, this new landscape provides new opportunities that when combined with an understanding of the structure of professional photography present the possibility of a creatively fulfilling, commercially viable career as a visual image-maker and problem-solver.

Photographer Emma Woodcock's love for shoes led her to focus on them as an area of professional photographic specialization. This conceptual image was created and photographed by her.

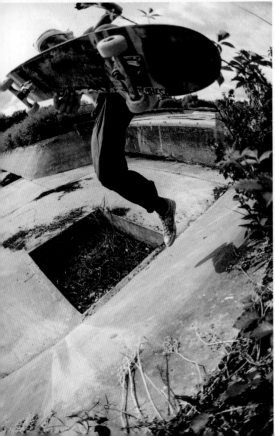

Photographer Robert Gifford is a fanatical skateboarder, so it was an obvious decision for him to focus on the sport as a professional photographer.

VISUAL PROBLEM SOLVING

A professional photographer and a professional photographic image are both visual problem-solvers, created and used to help a business sell a message, a story, a product, a celebrity, a lifestyle, a memory, a belief—in fact, anything that needs to be sold. This is the definition of the professional photographic image, and because its uses are so wide ranging it allows the professional photographer to create images that are equally diverse. However, the essential ingredient in all of your images must be the sense of who you are, your personal experiences, how you see the world. It is this sense that will make

It wasn't until the end of her photographic education that photographer Jen Rich focused on food photography. A keen baker in her spare time, she had never considered combining this hobby with her image making until it was suggested to her that she should consider and research food photography.

Photographer Kasia Fiszer discovered interiors and portrait photography through her love of making, craft and decoration.

The Three Types of Professional Photographer

The High-End Professional

They work with a cross-section of professional clients (as customers are described within professional photography), within one or across a wide spectrum of photographic genres. They are defined by a high-quality client base, which in turn results in strong financial reward for their work.

The General Professional

They work across a cross-section of professional clients within one or across a wide spectrum of photographic genres. They have a slightly less prestigious client base and therefore receive a lesser financial reward for their work. The general professional often aspires to be a high-end professional. They usually come from a creative academic background, and they are informed by the work of their peers. Both of these sectors are focused on creating, keeping and enlarging their commercial client base.

The Domestic Professional

They do not work for professional clients whose career it is to commission photography. They work in the wedding, events and domestic portrait market. This sector is most often self-taught, regionally focused and dependent on constantly finding new clients, as the clients they have rarely re-commission due to the nature of the reasons for their commissions. The domestic professional is an area that also appeals to semi-professionals, as they do not have to always be available for commission and much of the work is weekend-based.

I'm a documentary photographer. That's what I've always wanted to be; that's where my heart and soul is.

Photographer: Mary Ellen Mark

your work different from all of the other images being created, both amateur and professional.

To take these personal images into the professional world of photography requires an understanding of the professional worlds in which you would like your images to exist and the people who commission and pay for photography. Without a client of some kind photography is a hobby–it's a great hobby, but it will not pay your bills and provide you with a career. It is therefore essential to understand where the work you want to create will fit within the professional landscape.

The first fact you need to accept and understand is that your photography should be based on your personal passions. If you are a mad keen skateboarder, then start documenting your skateboarding friends and their lives. If you love music and seeing live bands, then document that; if you love cooking, then start recording what you cook; if you love shoes, then photograph shoes–I'm sure you've got the idea! Base your photography on the subjects you are passionate about and you will not only enjoy your photography, but you will also bring an understanding and insight into the subject you are photographing that someone else couldn't bring to the work.

It is these passions that will lead to your area of specialization and to developing a consistent, commercially aware body of work. Today's professional photography is about personality, defined personal language and specialization: those are the attributes that define a professional photograph, and you can't achieve any of them via an automated button.

The more pictures you see, the better you are as a photographer.
Photographer: Robert Mapplethorpe

CREATE A PHOTO SCRAPBOOK

1. To help you find your personal area of photographic specialization start by writing a list of any hobbies, interests and/or passions you may have.

2. Having done this, consider which of these will present you with interesting photographic opportunities and which that you feel most passionate about photographing.

3. Having defined an area you wish to explore start a scrapbook, filling it with images from magazines, advertisements, brochures, online—in fact anywhere you see images you like related to the area you have decided on exploring.

4. Look for photographers working consistently in your chosen area, find out whom their regular clients are and try to understand why they are getting commissioned so often.

This book will become not only your inspiration bible but also a great way of seeing where and how certain images are used in the professional environment. Once you have finished filling one book, start on another and keep on going, filling book after book. The more professional photography you look at the more you will start to understand what makes a professional photograph and a professional photographer.

Now you might be surprised or confused by my suggestion that you create an old-fashioned sketchbook created with scissors and glue

Areas of Professional Photographic Specialization
These are just some of the areas of professional photographic specialization that could be appropriate for you and your work, depending on your personal passions and visual language.

Portraiture
Fashion
Interiors
Still Life
Sport/Extreme Sports
Architecture
Food
Photojournalism
Cars
Weddings
Beauty/Hair
Reportage
Travel
Lifestyle
Music
Dance

and not utilize a digital platform such as a blog or an online destination such as Pinterest. The reason for this is simple and based on the rapid pace of changing technology and the requirements of educational institutions. A sketchbook is forever (I still have mine from 1985!) and a digital platform is not (I have information on mini discs, floppy discs, broken hard drives and all manner of equipment that you probably have not heard of and which I can no longer access). These sketchbooks should build into your personal visual inspiration library that you return to again and again throughout your creative life. They will also be an essential element of any application you may make to study photography at college or university level. They will demonstrate your passion for the subject, engagement with the subject and perhaps most importantly your willingness to do more than is required when it comes to self-motivated learning.

WHAT MAKES A PROFESSIONAL PHOTOGRAPHER?

MOST PEOPLE'S FUNDAMENTAL DEFINITION and understanding of a professional photographer is this: someone who gets paid to take photographs. In the most basic terms this is true. However, if you want to be a professional photographer, the questions you need to ask yourself are "Why should anyone pay you for photography?" and "Who pays for photographs?" Let's deal with these questions together, as each answer informs the other.

As I previously mentioned nearly every decision we make in our lives is to some extent informed and influenced by the creation of professional photographic images. The power of the photographic image to inform, educate and persuade is undeniable, and the creation of these images requires skill, understanding, commitment and hard work. But most importantly, professional photographs require a client and an audience. I have already spoken briefly about the concept of the professional photographer as a visual problem-solver, but let's discuss this idea in more detail.

Fashion is where I make my living. I'm not knocking it; it's a pleasure to make a living that way. Then there's the deeper pleasure of doing my portraits.
Photographer: Richard Avedon

WHAT IS A CLIENT AND WHAT DO THEY EXPECT?

A client can be any company, brand, shop, community, charity, individual and all others who have a problem they are looking to solve. They have a message that they want to convey, simply and directly. For example, they may want to sell a product, promote a service or illustrate a text. To do this they have decided to use either one or a series of photographic images. To create these they need a professional photographer. They will usually have a good idea of what kind

of images they want, how the images will look, what they will contain and where they will be created. Therefore they'll most often look for a photographer who has already created images similar to the ones they want. To find the right photographer, they will look at websites and portfolios created by professional photographers.

HOW DO PROFESSIONAL PHOTOGRAPHERS GET WORK?

At this point it is important to explain the way in which professional photographers work. The majority of professional photographers are employed on what is most often described as a freelance basis (you may also hear the term 'sole trader'; this refers to those who have established themselves as a business for financial reasons). This means that the photographer does not work for a company that pays a monthly or weekly salary; the photographer is paid only when asked by a client to take photographs on a one-off basis. This places a huge importance on freelance photographers' ability to market themselves to potential clients and to retain clients they have worked for previously. We will talk about how to approach this later in the book, but it is also worth stressing at this point that this kind of work can be sporadic in quantity.

My job as a portrait photographer is to seduce, amuse and entertain.

Photographer: Helmut Newton

So how does commissioning work? Well, the process is simple in theory, but as no set guidelines or rules are followed in practice, it can be both complex and frustrating, especially when you are starting out. In basic terms, the process goes as follows:

Clients Who Commission Photography
Nearly all commercially-used images are created by professional photographers, but you may not be aware of who is commissioning those images. Here is a list of some of the types of companies and organizations that commission professional photography, to help you understand how varied your potential client list could be.

Press relations companies
Magazines
Book publishers
Retail brands
Advertising agencies
Design groups
Charity organizations
Government organizations
Brand agencies
Arts organizations
Newspapers
Sports organizations

Where Do Clients See Photography?
Before you are asked to work for potential clients, they have to know about you and your work. Here are just a few examples of places that you should consider showcasing your work to begin your career as a professional photographer.

A well-designed professionally appropriate website
Photographic print and digital portfolios
Exhibitions
Photography festivals
Self-published books
Twitter
Flickr
Instagram
Well-written, professionally appropriate blogs on platforms such as WordPress or Tumblr

1. A client needs a photographer to take a certain type of photograph or photographs. The client is willing to pay for this.

2. The client will have decided on a total budget for the shoot and will not want to pay any more than what has been decided upon.

3. The client may have a rough or specific idea of what the photograph has to look like; either way, the client will set about finding a photographer who has already taken photographs similar to or the same as what the client wants.

You don't do something like this for money. I've never met anyone who's succeeded in life purely because they wanted the cash.
Photographer: Terence Donovan

THE COMMISSION

Once the client has decided upon a photographer to work with, the client will contact the photographer either by email or phone. The photographer will be told what the brief is for the commission and how much the budget is. The photographer will be informed how the images are to be used and the time frame within which the images must be created and delivered to the client. At this point the photographer has the option to accept or decline the commission.

If photographers accept a commission they may be sent a written brief, a copyright contract, a usage contract, a shoot schedule and a written budget—or they may be sent none of these! As I have said there are no rules to commissioning. At the end of the day it is the

photographers' responsibility to act professionally, protect their work, and ensure that they deliver what their clients expect without losing out either creatively or financially. This is much easier said or written than done, but I will outline some tips on how to deal with clients in Chapter 6.

WHAT IS THE EXPECTATION OF THE PROFESSIONAL PHOTOGRAPHER?

The world of professional photography can loosely be divided into two areas of commissioned photography: editorial and advertising. Simply put, editorial photography is commissioned by magazines and newspapers in both printed and online form and is focused on either supporting written content or providing a visual storytelling narrative. Advertising photography is commissioned to sell products, brands and ideas. Traditionally, the editorial environment was less well paid but provided more creative opportunities while advertising work was better paid but more restrictive creatively.

However these areas no longer have such strict definitions, and photographers can move between these genres of work much easier than in the past. However, along with the convergence of these areas has come a convergence of expectation. Both editorial and advertising work has become more creatively restrictive and less well paid as clients become less willing or able to take creative risks. This conservatism in commissioning has had a far-reaching effect on the type of work that is commissioned as well as created. This does not mean that exciting work is not still being created; however it does mean that this work is less likely to be seen in connection with traditional platforms such as large-scale advertising campaigns and magazines published by mainstream publishers.

Who Commissions the Photographer?
You could be contacted and professionally commissioned by a variety of people, with many different job titles. Here are just a few:

Art Director
Creative Director
Fashion Editor
Stylist
Photo Editor
Picture Editor
Researcher
Editor
Journalist
Art Buyer
Designer
Homes Editor
Publisher
Home Economist
Marketing Assistant

People buy ideas, they don't buy photographs.
Photographer: Annie Leibovitz

The basic expectation of professional photographers is that they are professional in all aspects of their practice, from social media use to delivery of the finished image and the shoot itself. They must be able to work with a client, to understand the client's needs and to be able to interpret those needs into a mutually pleasing outcome. Remember:

- **Be polite, friendly and socially confident.**
- **Be able to work as a team and be open to interpreting other people's ideas.**
- **Be willing to work long hours and be patient when dealing with unrealistic expectations.**
- **Be technically confident and creatively engaged.**
- **Be willing to work independently to market yourself and your work.**
- **Be open to and informed about new developments in digital capture and communication.**
- **Be passionate about the subject matter you choose to photograph.**
- **Be able to show empathy to the clients you work with and the people you photograph.**

If you are able to respond positively to all of these requirements, you are well on your way to understanding the expectations of a professional photographer. It is no good being a great photographer and not being able to fulfill these requirements. The world of professional photography requires both an ability to create great work and an understanding of its professional expectations.

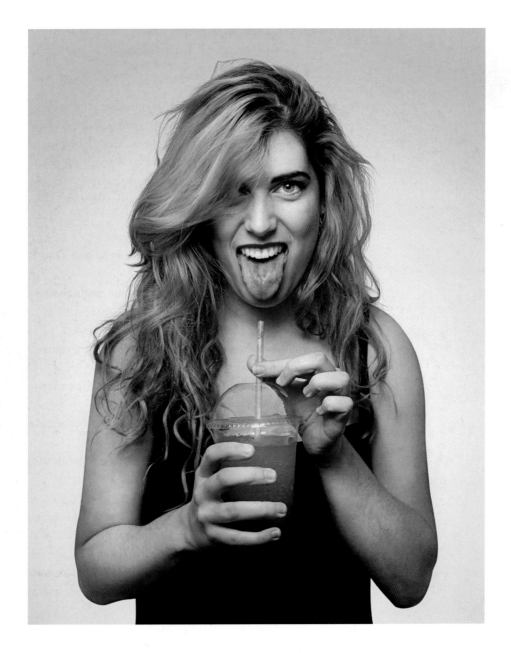

This conceptual image created by photographer Tash Parsons shows not only the impact that a simple idea can have but also the requirement for post-production ability when working on an idea-based image.

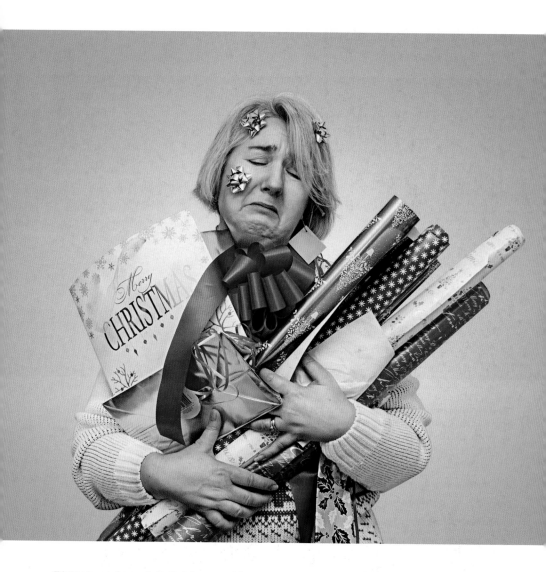

This image was also created by Tash Parsons and demonstrates the importance of bringing a unique perspective to familiar subjects. In this case Tash was responding to the act of Christmas shopping from her perspective.

SET YOUR OWN ADVERTISING BRIEF

This single image constructed from three separate images by photographer Emma Boyns forms a narrative triptych that effectively demonstrates an extremely creative approach to a simple subject matter.

An effective way in which to find out where your photographic career may lie is to challenge yourself with a realistic brief from a specific area of commissioning. Here I have outlined a brief that will give you an insight into working within the advertising environment.

1. Decide upon a product you are interested in and have bought. This could be anything from a pair of trainers, a bicycle to a piece of clothing—anything at all that you feel will give you an interesting visual challenge to photograph. Think about what appealed to you about the product and why you bought it.

2. Once you have decided why you bought this product, start writing down ideas of how you could express that reason as a photograph. When doing this consider where the photograph will appear. Will it be an advertisement in a magazine? If so, which magazine? Will it be a billboard? Will it appear online as a banner advertisement? Will it be on a bus stop or on the side of a bus? These are all places where advertising photography appears.

3. When you have decided upon an end destination for the image and a creative approach, then put together a team to help you reach as professional an outcome as possible. This may entail asking friends to model for you, help you with styling, find locations and/or help you with equipment.

4. When shooting make sure that you shoot your original idea, but be open to trying different ideas on the day and experiment with different approaches to solving the problem you have set yourself. Make sure that you do not shoot too few options and frames.

5. When you edit everything you have shot look to choose approximately five to ten images that you feel have fulfilled your brief. (Note: 'Edit' means to choose images, *not* to edit images in software like Photoshop. The professional terminology for editing images with software is 'post-production.')

6. Show these edited images to some friends who will be honest with you, and ask them if they feel you have succeeded in creating images that would make them buy the product.

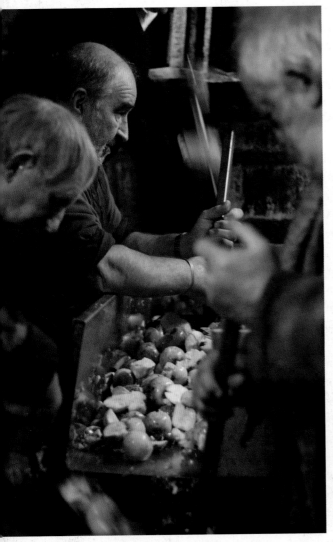

This extended narrative of portraits and observational images created by photographer Abbie Stewart was created within a drinking club that her father attends. It is a fantastic example of the visual possibilities that one location can offer, and of the importance of immersing yourself into the environment you choose to record.

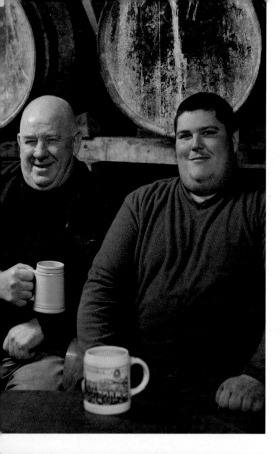
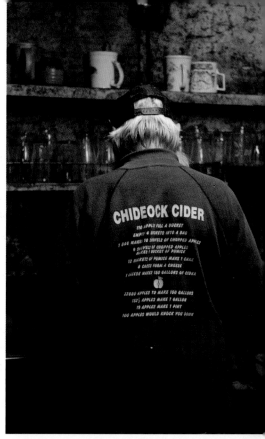

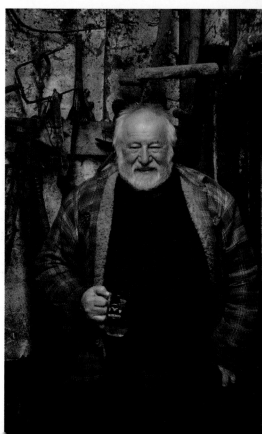

SET YOUR OWN EDITORIAL BRIEF

An effective way in which to find out where your photographic career may lie is to challenge yourself with a realistic brief from a specific area of commissioning. Here I have outlined a brief that will give you an insight into working for magazines.

1. Choose a magazine that covers subjects that you are interested in. This should be a printed magazine, not an online one.

2. Within that magazine decide upon an article that features a story similar to something you would like to photograph. Look at how many images the article features, how the images are used and how many pages composing the article.

3. Decide upon the story you want to photograph, and think about how long it will take you to photograph the story. Will it require just one shoot? Repeated shoots? Just a day, an hour or many days?

4. Once you have made this decision, research the story. Which other photographers have photographed the subject matter you have chosen, and how have they approached the brief you have set yourself?

5. As with the advertising shoot, ensure that you shoot your original idea and options that will present themselves while you are on location. Ensure that you do not edit yourself on the day; keep shooting, and allow the narrative you are creating to have lots of visual possibilities.

6. When you edit everything you have shot, choose approximately ten to twenty images that you feel have fulfilled your brief. (Note: 'Edit' means to choose images, *not* to edit images in software like Photoshop. The professional terminology for editing images with software is 'post-production.') Then see if these would work within the article you used as your initial template and inspiration. Then edit your ten to twenty images down to the number used in the article, considering where they would be used within the article.

7. Show these edited images to some friends who will be honest with you, and ask them if they feel you have succeeded in creating an article that they would read and find visually interesting.

You have to devote yourself totally to be successful at it.
Photographer: Elliott Erwitt

HOW TO PROGRESS PERSONAL PROJECTS

If you like the idea of progressing your personal projects and visions to create exhibitions and self-published books primarily supported by grants, bursaries and independent funding, you will need to immerse yourself in the photographic community already working in that way. This has never been easier to do and could be seen as one of the reasons why so many young photographers are attracted to this way of working. Social media platforms such as Twitter and Facebook are full of photographers talking about their personal work, sharing it and collaborating with others with similar intentions. The use and importance of social media is something that I will focus on in more detail later in this chapter.

Photographic festivals, seminars and talks are now happening globally, from large-scale annual events to small monthly self-initiated gatherings. There is an event out there for anybody and everybody interested in photography, and these can be useful for many different reasons.

If you are working on personal projects you will want to talk about what you are doing with others working in a similar way on similar projects. This will introduce you to the idea of socializing with fellow photographers, to share technical advice and photographic experiences and most importantly to become part of a mutually supportive photographic community.

Recommended International Photography Festivals
As I have mentioned there are many local opportunities to meet fellow photographers working on self-initiated projects, but there are also a large number of international events that members of the global community attend to share their work and meet, talk and support fellow photographers of varying degrees of experience. You may not be able to visit these festivals in person, but they all have websites so check them out! If these whet your appetite turn to the back of this book for even more festivals you could attend or find out about.

Helsinki Photography Biennial: Finland
PHotoEspaña: International Festival of photography and visual arts: Spain
PhotoIreland Festival: Ireland
Rencontres d'Arles: France
Perpignan: Visa pour l'Image: France
São Paulo Photography Fair: Brazil
Photo London: United Kingdom
Format, Derby: United Kingdom
Brighton Photo Biennial: United Kingdom
PhotoNOLA, New Orleans: United States
Angkor Photo Festival: Cambodia
MIA Fair: Singapore
Paris Photo: France and United States
Unseen Photo Fair, Amsterdam: Netherlands
Filter Photo Festival, Chicago: United States
Photo Shanghai: China

These series of images form part of a much larger body of work created by Bulgarian-born but UK-based photographer Venislav Petrov. He works on a number of different narratives at the same time but all concern his past and present living environments. His *Searching for Veni* series progresses this exploration further, as he includes himself within the image at a scale almost impossible to see.

THE IMPORTANCE OF TEAMWORK AND BEING A TEAM PLAYER

A good friend of mine who is a successful photographer has always believed that the process of creating photographs is the most selfish creative act of all of the creative acts. Why? Because one eye doesn't even share what it is looking at with the other eye as it looks through the viewfinder. This idea of the photographer as a selfish, controlling and isolated character creating images that only please him or herself is one that photographers always deny but one that in the past has been both a creative and commercial option. (I could name a number of successful photographers who have displayed at least one of these personality traits throughout their careers!) However, this is no longer an option for the professional photographer in the twenty-first century.

The democratic nature of photography today means that everybody has the opportunity to create photographic images to a reasonable technical quality, and this has resulted in a situation in which everybody is an 'expert' and everybody has an 'opinion' without necessarily having the appropriate understanding of how to create the image they can see 'in their heads.' This requires the professional photographer to deal not only with the creation of the image but also with all of the people who have any client connection with the creation of that image. You may be the one looking through the camera, but you will probably not be the only one. You should always look through the viewfinder to frame and compose your image when possible, but you will inevitably use the screen on the back of the camera to review that image for both technical and aesthetic reasons. When you look at that image the client who may well be on the shoot with you will also expect to look at that image and express his or her opinions.

If you are working in a studio or on location you may also be expected to work 'tethered.' This will require you to work linked to a computer either physically or via wi-fi, enabling your images to be instantly

transferred to a computer screen for client approval. There are many issues with this way of working that I will discuss in Chapter 6, but the ability to work within a team and lead that team is now an essential element in the photographer's kitbag.

If a photographer cares about the people before the lens and is compassionate, much is given. It is the photographer, not the camera, that is the instrument.
Photographer: Eve Arnold

ESSENTIAL TEAM SKILLS TO LEARN

1. Diplomacy: The ability to express opinions firmly but politely while also listening to the opinions of others. This may also require you to shoot in a way that you don't agree with, a situation that you can handle in many ways as long as you are always polite and never forget that your role is to work 'with' the client who is paying your fee.
2. Empathy: You need to understand the client's position, perspective and background. You then need to respond appropriately.
3. Leadership: It is essential that the photographer leads a shoot. You have been employed for your skills and ability to create images, and the client will expect you to be confident and sure in your decision-making and problem-solving skills. However, the client will not want you to be arrogant, self-opinionated or rude to your assistant or fellow members of the creative team. There is a hierarchy to a photo shoot, and the client and photographer are at the top of that hierarchy, but this should not be seen as a reason for rudeness.

It is not only the client or clients that provide photographers with personal interaction challenges on a shoot. As a professional photographer you will be working with stylists, art directors, hair and make-up artists, prop builders, assistants, studio technicians, editors, writers, rental companies, studio managers—in fact a whole range of people from the creative industries who will help you create and bring to life your photographic images. Different shoots will have different requirements, but most photographers will have a core team of people they can call on to work with on a regular basis. As you can probably tell, creating professional photographic images is not just about pressing a shutter!

WHO MIGHT I NEED IN MY TEAM?

Who you have in your team and how big your team is will be defined by the area of photography you decide to specialize in, but here is a short list to give you an idea of the people you may need or want to work with.

- **Assistant:** The role of the photographic assistant has traditionally been one that has been seen as a starting point for young photographers to 'learn the trade' before starting to work as professional photographers with their own clients. The digital age has changed this role dramatically. Today many photographers work without assistants, and clients refuse to pay for them, leaving photographers to pay assistants out of their fee. Those that do still work with assistants still use them to set up and adjust lighting equipment, check that cameras are clean and batteries charged and complete general duties around the shoot from getting coffee to holding a reflecting sheet. They will also expect the assistant to be able to download images accurately and safely from memory cards and open them for review in software packages such as Photoshop, Lightroom or Capture One among others. An assistant may also be expected

to drive the photographer to and from shoots, upload images to social media platforms during the shoot and create images of the shoot to be used online by the photographer or client. The good assistant is seen and not heard and always one step ahead of the photographer's needs and requests.

- **Stylist:** In editorial fashion photography the stylist will provide the clothes for the shoot, source the models, arrange the location and source any props that are required. The position will hold the title of stylist, junior stylist, fashion editor or fashion director. In other areas of photography the stylist will usually only be responsible for sourcing props, consulting on shoot location and fulfilling a set creative brief. However, as with all areas of professional photography, there are no set rules or responsibilities.

- **Hair and Make-Up Artists:** If you are going to photograph people for a commercial client the chances are that you are going to need to work with a hair and make-up artist. From an extremely creative full-force make-up to a brief 'clean-up,' the skills of a good make-up artist can be essential to the atmosphere and outcome of a shoot. For this reason it is important that there is a mutually respectful relationship and creative understanding between the photographer and the hair and make-up artist. Some make-up artists will be able to handle both hair and make-up, but if more creative approaches are required for the hair a specialist hair stylist should be used.

- **Post-Production Technician:** The role of post-production in image creation has grown rapidly since the advent of digital capture. It has also become a highly skilled and important art form. It is therefore not something to attempt unless you are highly competent in all areas of this work, from implementation to client delivery. Many photographers do not have this competency and therefore work with post-production technicians and artists before submitting their finished images to their clients.

Essential Pro Kit
Whatever you do, please do not go and buy this kit now or think that you cannot start your journey into the world of professional photography without an expensive kit. However, this is a list of the minimum kit you are going to need when you start to work as a professional photographer.

Two DSLR Pro Bodies: Canon EOS 5D, 5DMKII, 5DMKIII, 1DX, 1DC or earlier models from the 1 Series, 7D, Nikon D4, D3X, D3s, D800, D800E, D7100, D7000.

A selection of prime lenses appropriate to your area of work. These should be as fast as you can afford up to 100mm. You should avoid telephoto lenses and bundled lenses where possible, although a 70–200mm is a good portrait lens used by many pro photographers.

At least one light meter: Sekonic or Minolta.

Two fast CF and SD card readers: Sandisk or Lexar.

A selection of CF and SD cards from 4GB to 64GB. The larger-size cards are required for moving-image storage. You also need to ensure that you have the pro versions with fast download rates.

A solid, general-purpose tripod with fully adjustable, quick-release head.

At least two external hard drives.

A heavy-duty camera case, preferably on wheels. Look to find one that can be accepted as hand luggage for flights.

If you thought that the role of being a professional photographer was just about taking photographs before you started reading this book by now you are probably starting to see that taking photographs is the easy bit! The role of the professional photographer today is far more complex than just taking photographs. It requires good social skills, confidence in personal communication and an interest in people and the world that surrounds you.

I'LL BE YOUR AGENT!

The role of the photographic agent is often misunderstood by those who have never had one, but ask any professional photographer who has been represented by a good agent and he or she will tell you that an agent can be the difference between an average career and a very successful one. Unfortunately, you will also find many photographers who are just as willing to tell you their horror stories of being represented by a bad one.

There is no qualification required to begin working as a photographic agent—all you need is a website, a telephone, some photographers willing to be represented and off you go! And this is the problem with many agents: they start off thinking that it will be easy to find work for their photographers, accept a commission for doing so and make a comfortable living for both themselves and the photographer. Sadly, this is not the case. A good agent needs to be well connected within the industry, have a database of existing and potential clients, be willing to work hard and have the experience to deal with every aspect of creating a shoot, from finding impossible-to-find props, securing international work visas, to dealing with complex copyright law. A good agent is invaluable, but do you need one? And how do you get one?

A good agent needs to be passionate about photography and also a persuasive, creative and shrewd businessperson. An agent therefore rarely takes risks with young photographers until they establish a client base and prove their ability to get commissions, keep clients and make money. Young agents usually look to represent young photographers, and established ones tend to look towards established photographers, but either way your expectation of being represented by an agent should be realistic and based on the track record of the agent you are speaking with.

Great work and a strong client base will always attract agents whatever age you are, but before you commit yourself to one be aware of these facts:

1. **Agents will expect to take on any clients you are working with and add them to their client base.**
2. **They will take a percentage of your fee for any job you do even if it is for a client they did not find for you.**
3. **They will expect to be involved with the choice of images in your portfolio and on your website and often have the final say.**
4. **You will be charged for delivery every time your portfolio is sent to a potential client. This may incur expensive motorbike couriers and international postage.**
5. **You may be asked to work with fellow creatives because they share the same agent, not because they are your first choice.**
6. **They will expect you to spend on marketing material such as postcards and mail-outs that they organize.**

HOW TO FIND YOUR PHOTOGRAPHIC VOICE

THE FILM (OR, AS it is commonly known, analogue) camera business reached an all-time sales high in 1999. In that year, people around the world took 80 billion photos and bought approximately 70 million cameras. In 2014, it is estimated that 90 million compact and DSLR cameras were sold and approximately 2 billion phones and tablets with cameras; over 2 billion iPhone and Android smart phones were sold by the end of 2014. That's a lot of people with cameras in their hands taking photographs and sharing them online!

> *It's not the camera that takes the picture;*
> *it's the person.*
> Photographer: David Bailey

Over 1.5 billion new photos are shared every day on Facebook, WhatsApp and Snapchat alone, which equates to about 550 billion a year, and this number is growing fast. So what does this mean in relation to what was happening in 1999? Well, it means that more than twenty times more devices that can take pictures were sold in 2014 than in 1999. At least more than twenty times more photos were taken than in 1999, and it is possible that more photos will be taken in 2014 and in following years than were taken on film since the birth of photography.

With all of these images being created and the number of images being created growing at an awesome rate, how can you, as a young photographer, create images that stand out from the crowd and establish yourself as a professional photographer? The answer is by finding your own photographic voice.

*It is part of the photographer's job to see
more intensely than most people do. He
must have and keep in him something of the
receptiveness of the child who looks at the
world for the first time or of the traveler who
enters a strange country.*
Photographer: Bill Brandt

WHAT IS A PHOTOGRAPHIC VOICE?

How do you find your photographic voice? And for that matter,
what is a photographic voice? My interpretation of this term is
that your photographic voice is the way that you see the world,
and how you see the world is informed by your life experiences so
far—your passions, your interests, where you live, your family, your
school, your friends, your dreams and your aspirations. All that stuff
combined together makes us who we are and how we view situa-
tions, places and other people—it is what makes each of us unique.
If you can then bring all of these influences to your photography,
your photography will also be unique: you will be creating a visual
language that is unique to you, and you will have developed a
photographic voice.

*Don't be swayed by fads or fashions—be true to
your own vision. Respect the past and the history of
photography.*
Photographer: Robin Broadbent

WHAT INFLUENCES YOUR PHOTO VOICE?

As I have mentioned it is what influences you and what you are interested in that will help you find your photo voice. Here are some questions to ask yourself to help you achieve a clear understanding of what your influences are and how they can inform your photography. It is a good idea to write the answers to these questions into a notebook and look to see if a pattern emerges that might lead you to a specific genre of photography that you would enjoy exploring.

1. What music do I like?
2. What films or TV programs do I watch?
3. Am I interested in global or local news?
4. What magazines do I like, and which websites do I visit regularly?
5. What was the last exhibition I visited?
6. Do I enjoy having conversations with people?
7. Is fashion important to me? Do I know the latest trends on the catwalk?
8. Do I enjoy controlling situations, or do I prefer to observe?
9. Do I enjoy travelling or staying at home?
10. Am I adventurous in the food that I eat and do I enjoy cooking?
11. Am I involved in sports?

There is only you and your camera. The limitations in your photography are in yourself, for what we see is what we are.
Photographer: Ernst Hass

You do not make a photograph just with a camera. You bring to the act of photography all the pictures you have seen, the books you have read, the music you have heard, the people you have loved.
Photographer: Ansel Adams

Creating a list of answers to these questions should identify potential subjects for you to photograph that you are interested in outside of your interest in photography and give an indication of areas of photographic practice that this work may sit within. Once you have these you are ready to start creating images outside of the context of academic requirement and/or holiday snaps. Your new context will be of the potential professional photographer. However, to understand what this context is and means requires research and lots of it, both online and in traditional libraries, news agents and bookshops. Once you have found out the kind of images you want to create it is essential that you find out how other photographers approach the same subject matter and stories. You need to find out which other photographers' work you like, how they create their images both technically and aesthetically, where the images appear and how they are used and by whom. It is this research that will help you make the jump from photography as a hobby or college subject to being a possible career.

LOOKING AT OTHER PHOTOGRAPHERS' WORK

Finding out about different photographers and the way that they work has never been easier, thanks to the Internet. However, you are only as good as your Google search terms when looking online, so it is important that you look elsewhere for your inspirations as well. If you see a photographer's work that you find interesting, go to his or her website, find out who he or she works for and see if you can find interviews with him or her online. These may be podcasts on iTunes or filmed interviews on YouTube or published in photographic

magazines and on specialist websites. Follow these photographers on Twitter and look to see whom they follow and who is following them; by doing this you will be entering a community of like-minded souls that you can learn from and engage with as your work develops. You might even get to the stage where you will feel confident enough in your work to ask for advice from them. This access to your photographic heroes is an incredible resource that could be invaluable in the development of your photographic voice.

Photography for life, it's not a job, believe me.
Photographer: Steve Pyke

What you will find when you start looking at the work created by professional photographers is that their careers and bodies of work are consistent in their quality, subject matter, approach and most importantly their storytelling. It is very rare that a commission or project required the photographer to create just one successful image. Photography is a storytelling medium, and although it is true that one image can tell many stories, it is also true that one photograph can only tell those stories from one perspective and that the full story requires a series of different perspectives. These perspectives come from the creation of a series of images or a narrative that when viewed as a whole becomes a body of work that reveals everything about the story you feel is important. It is the same as reading a novel. One chapter can be fantastically written and informative, but without the other chapters you will not know what the story is. A visual narrative is just like a novel; it needs to engage the reader and tell the story you want to tell.

Be subjective and personal. Be more adventurous.
Look around your own area, and look again at the
things you know.
Photographer: Martin Parr

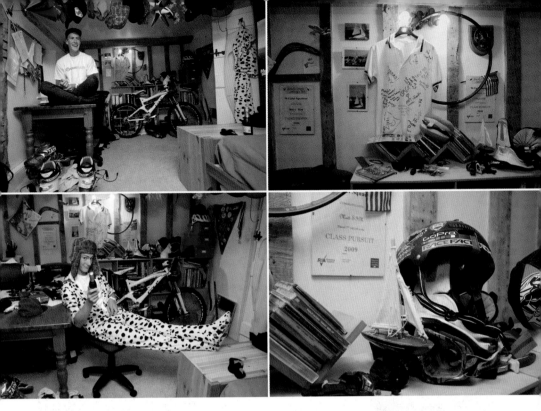

Photographer Beth Dooner is an avid follower of and participator in the Cosplay movement, regularly attending events and meeting fellow fans of this highly creative genre of films, novels, fanzines and comic books. It was therefore a natural progression for her to start documenting the people who attend the events. These early experiments have developed into a series of documentary narratives within the Cosplay scene and its associated areas of interest.

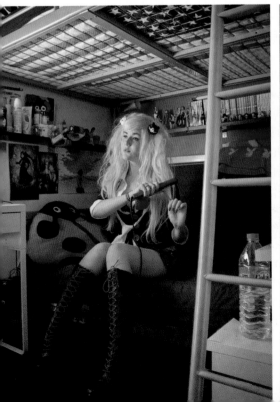

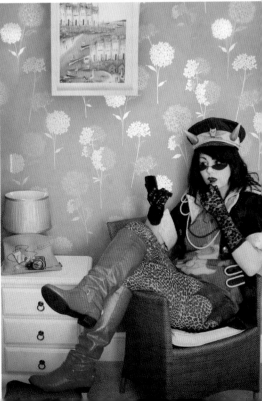

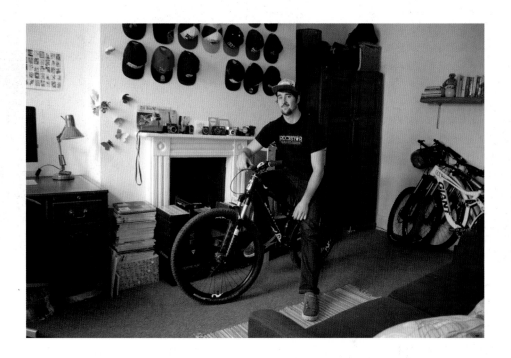

As well as an interest in interiors photography, Kasia Fiszer brings her passion for mountain biking into her photographic practice. She connects this work with her commissioned interiors work by focusing on the lives and homes of the people she knows within the mountain biking community.

CREATE A VISUAL NARRATIVE

To help you begin creating your own visual narratives, I have written these two tasks for you to complete.

1. Create a series, consisting of a minimum of six images, which illustrates one story and demonstrates your possible area of photographic specialization based on your passions. You should consider what your passions are before deciding on an area to explore. These could include fashion (men's, women's or both!), portraiture, styled portraiture, food, sports, styled/conceptual still life, architecture, interiors, social documentary, dance, even dogs!

2. Create a series of fifteen images that tell a story and demonstrate a visual narrative. This can consist of portraits and/or still lifes and/or landscapes.

You can choose any story to tell, but you need to concentrate on creating a visual narrative and individually strong images.

THE VISUAL NARRATIVE

The creation of narratives and a consistency of quality image creation are, I believe, the two most important attributes that define a professional photographer today. They are skills that the amateur and enthusiast rarely consider, and yet they are evident in all successful professional photographers' work. The importance of narrative is clear in the iconic social documentary work of photographers such as Sebastiao Salgado, James Nachtway, W. Eugene Smith and Walker Evans and the contemporary work of photographers such as Andreas Gursky, Alex Webb, Martin Parr and Edward Burtynsky among many others. (By the way, if you

Although these two images are part of a larger body of work created by photographer Tash Parsons, they also work well as a contained diptych narrative.

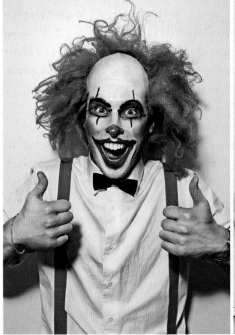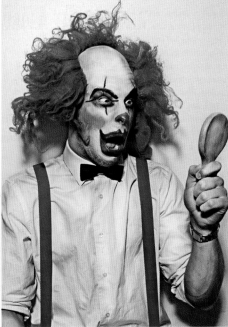

don't know these photographers and their work then look them up!) But it is also important in all other forms of photography: from fashion to food, from sports to architecture, the photographic series is essential to visual storytelling and therefore to your photographic voice.

DEVELOPING A PROJECT

If you have attempted to create a visual narrative in response to the brief I have set you, then you have begun to create a project. So what is a photographic project, and why is it important for photographers to create them?

I hope that by now you are seeing that by following the briefs I have set for you, progression to becoming a photographer is one of commonsense evolution. First, you find a subject that inspires you, then you begin to photograph that subject as a series of images to explain to others what you find so interesting about that subject. By doing this you are exploring genres of photography you enjoy, but you are also becoming more involved in your subject, and it is at this point that you may decide to focus on one element of that subject. It is by focusing in on this defined element that a project is born.

Projects can be inspired by emotional connections or intellectual connections with your subject matter. You may want to express how others feel or explore why things are as they are. It is your call as to what you want to turn into a project and how you want to do it—there are no rules. Similarly, it is up to you as to how long you want to spend on a project. You might want to spend just one hour (a short-form project) or the rest of your life (a long-form project) documenting your chosen subject. Again, the decision is up to you, but you will probably find that the subject will inform these decisions as will your feeling about the work you create.

ICONIC PHOTOGRAPHIC PROJECTS

Research is always the foundation for good work, so to help you get started with your project here are some of the best to get you inspired. Just type these photographers' names and their projects into a search engine to find out more.

Richard Avedon: *In the American West*
Maciej Dakowicz: *Cardiff After Dark*
Larry Clark: *Tulsa*
Stephen Shore: *Uncommon Places*
Edward Burtynsky: *Oil*
William Klein: *New York, 1954–55*
Jeurgen Teller: *Go Sees*
Paul Reas: *I Can Help*
Larry Sultan: *Katherine Avenue*
Mary Ellen Mark: *Prom*
Julia Fullerton Batten: *Mothers and Daughters*

Photographers working on projects can spend many years working on a single project alongside all of their other work and therefore create vast numbers of images. It is rare that great single images and a great series of images come from pressing the camera's shutter only a few times. It is quite normal for professional photographers to shoot many thousands of images as part of a project. They allow the project to develop visually, only deciding which images are successful when they come to edit all of their material into a cohesive body of work. The process of choosing images is called 'editing,' and it is one of the most important skills a photographer needs to learn.

Always keep learning and experimenting, don't delete anything. Keep all of the outtakes somewhere safe.
Photographer: Dafydd Jones

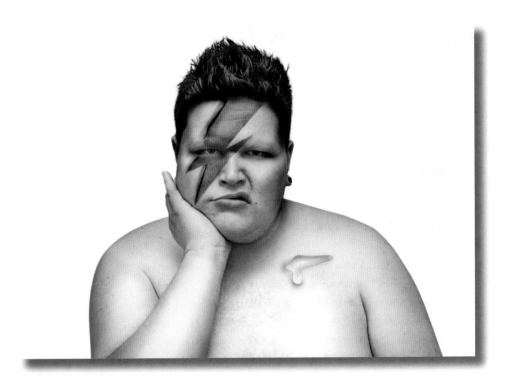

This homage to the iconic David Bowie album cover *Alladinsane* was created by Tash Parsons and is titled *Alladinpain*. It was an early experiment for her in creating highly post-produced conceptual images, but it still shows a high level of post-production expertise.

WHAT EDITING MEANS

I often hear young photographers refer to adjusting photographs in Photoshop as editing. It is not! That is post-production, and it is essential within the world of professional photography that you use and understand the correct language to use when referring to the processes of photography. Choosing the right image to show someone is the most important part of becoming a photographer, but it is amazing how few photographers know what their best work is. This often results in people not presenting their best work and being judged not on their photography but on their lack of editing ability.

Buy good photography books and make time to see good exhibitions.
Photographer: Mark Power

Whatever images you think are your best are okay with me in photography; two plus two rarely equals four, and all decisions are subjective. (Remember this when people are commenting on your work. Stay true to what you believe but listen to those whose experience and knowledge you respect.) However, gaining experience by looking at other people's images will help you edit your own work, as will this simple step-by-step process:

HOW TO EDIT YOUR IMAGES

1. Make a rough edit of your images on your computer screen using a software program that allows you to rate your images with a star system or something similar. Make sure that you look at all of the images at full screen size, and pay particular attention to all areas of the image not only the central subject. Once you have done this make cheap A4 printouts of your five-star images. The number you print out will depend on how many images you are editing from, but you should consider having at least thirty to forty printouts.

2. Once you have your printouts find a large space (this could be a garden, garage, hallway, etc.) and lay all of your prints on the floor, grouping portraits together, observational images together, environmental images together and ensuring that any other images that cover a similar subject are also grouped together.

3. Review each group, looking for repetition of image and weak and strong images. Remove the weaker images and reduce each group to only the strongest images. At this point you have to be tough: consider only the quality of the image not the emotional or financial implications of editing out a particular image. This stage should leave you with enough images to see how your project is developing, what you need to shoot more of, what you have covered well and where you need to improve. As such, this editing process is one to repeat throughout your project not just at the end!

4. When you have decided upon a final edit of images that indicate that the project has come to an end, you could start to look at putting the images together as pairs or in an order with the idea of perhaps creating a book or exhibition of the work.

Don't think about style. It's all bullshit and surface stuff.

Photographer: David LaChapelle

BE CAREFUL WITH POST-PRODUCTION EFFECTS AND TECHNIQUES

One of the phrases I hear most from student and young photographers when defending their work is this: "I haven't got a style yet." No one should feel they need to have a style! Finding your photographic voice goes much deeper than finding a style; your photographic voice is based upon who you are, what you see and what you do.

The idea of a style sounds and seems shallow, and the only photographer's work that I have seen and could actually describe as having a style is that based on post-production manipulation of an image based on somebody else's work. There is no doubt that the digital post-production revolution that began with the advent of digital photography has seen new photography aesthetics develop and new areas to explore for those interested in photography.

This has resulted in highly skilled post-production artists who work with photographers, and photographers who enjoy post-production, basing their photographic visual language around image manipulation. This is a new and interesting area of image creation that extends photography's visual possibilities, and there has been some incredible work produced, but that work demands the highest

quality of re-touching skills, huge amounts of patience and often many hours of concentration. It is this dedication to image creation and manipulation that makes these images so successful both creatively and commercially. However, without this skill and dedication to post-production perfection, post-produced images can often look clumsy and generic, relying on simple-to-learn basic Photoshop techniques. It is this approach to 'finding a style' that I see so often, and it is one to be avoided. Your style will not and should not be based upon a technique.

These effects are constantly being improved upon as professionals look for new ways to creatively extend their work, and post-production work is highly competitive. This means that the techniques you are learning are quickly being superseded and becoming outdated. I am not saying that you should not explore post-production and image manipulation as an art form, just don't look to it as a 'quick fix' to find 'a style.'

All the technique in the world doesn't compensate
for the inability to notice.
Photographer: Elliott Erwitt

CHAPTER 4

UNDERSTANDING THE PHOTOGRAPHY BUSINESS

YOU CAN TAKE PHOTOGRAPHS of whatever you want, you can take them however you want and you can enjoy your photography without interference from others or listening to the opinions of others. That is, if you do not want to earn your living from photography. Photography as a business is incredibly rewarding creatively, but it does have guidelines, rules of engagement and expectations of the photographer. All of this can be easily understood, and the better your understanding, the more likely it is that you will be able to adapt your personal approach to photography to the business of photography.

If you like the idea of earning money from your photography and maintaining your creativity, it is now possible to work in many different ways. You could work for clients who commission you to take pictures for them; you could work purely on your personal projects supported by grants and bursaries; you could set up your own business and offer your services to your local community. You can work in any or all of these ways. The choice is up to you, but your expectation of creative and financial return will be determined by the way in which you chose to work within the photographic industry.

It's a choice—there are two different sorts of photographer: those obsessed with the technicalities and those obsessed by the subject.
Photographer: Mario Testino

WHAT DOES PHOTOGRAPHIC SPECIALIZATION MEAN?

There are general areas of photographic practice that you will probably be aware of, such as portraiture, fashion, still life, landscape and documentary. These are broad brush-stroke descriptions, but within

each category there are many areas of specialization. For example, you might enjoy working in a studio environment arranging lighting set-ups and want to focus on still life photography. That is fine, but what are you going to photograph? As we have already discussed, your passions will lead you to what you are going to enjoy photographing. So if you enjoy cooking, food and collecting styling props you will probably start photographing food. If you love buying and collecting shoes, you will probably want to shoot shoes. Both of these are specialist areas of professional photography. If you want to photograph food you are on your way to being a food photographer with the potential of working for magazines and advertising clients. If you enjoy shooting shoes, you are on your way to being a still life photographer specializing in shooting shoes and associated fashion accessories.

> *To get rewarding work, change your portfolio often and try and include as much self-initiated work as possible. If you do that, you are more likely to get commissioned to do something you are interested in.*
> Photographer: Mark Power

The belief that you have to photograph lots of different things to show that you can do this and to prove that you are a 'good' photographer and to give a client lots of reasons to commission you is a myth. You need to start off by doing one thing really well, and over time if your work develops and evolves you may move into different ways of working, but at the beginning keep it simple.

There is a really easy metaphor to use to understand why it is so important to specialize from the beginning of your career: Imagine you want to buy a new pair of running shoes. You want a good pair that are right for you, and you are looking for expert advice and

service to ensure that you get what you want at a price you are able to pay. To make sure you get this you would go to a specialist running store that would look at how you run, what you weigh and what your expectation is of the shoe. You are their client. You could, of course, go to a department store or supermarket to buy your shoes, where the price may be more competitive and the range attractive, but you will not receive the specialist service and product you require. As a client you will be disappointed. Professional photography works in exactly the same way. The people who work in the specialist running shop are passionate about their subject and that comes through in how they do their job. That's how you should feel about your photography and how your client should feel about you.

Your client will always appreciate genuine creative interest in their product.
Photographer: Patrice de Villiers

FINDING YOUR PHOTOGRAPHIC SPECIALIZATION

Different areas of photographic specialization include different genres of work, so don't feel that by specializing you are preventing yourself from working in different genres. You're not! You're placing your work within a professional photographic context. To help you understand this process I have compiled a list of specializations with the genres of work you can explore and what will be expected of a photographer working within that area. As you will see, most areas of specialization include the main areas of photographic practice.

1. Fashion photographer: portrait, documentary, landscape.
2. Sports photographer: portrait, documentary, landscape.
3. Architectural photographer: documentary, landscape.
4. Still life photographer: still life, landscape.
5. Food photographer: portrait, documentary, still life, landscape.
6. Music photographer: portrait, documentary.
7. Social documentary photographer: portrait, documentary, still life, landscape.
8. Portrait photographer: portrait, documentary, landscape.
9. Interiors photographer: portrait, still life, landscape.
10. Photojournalist: portrait, documentary, landscape.

As I will explain later in this chapter, the visual blog can be a useful and inspirational tool when it comes to exhibiting your more personal work, but it should not be confused with the importance of a collection of other people's work devised purely for your own inspiration.

MAKE A SPECIALIZATION IMAGEBOOK

To help you see how each area of photographic specialization can include different genres of work, why not choose a group of photographers working in the area of specialization you are interested in and look at each photographer's work individually? Look at their work carefully and identify the different areas of their work as I have outlined in the list above. This may be easier than you think, as many photographers will have done the job for you by creating specific sections on their websites.

Once you have identified the different areas from different photographers, put all of the images together that fit one specific genre of work. For example, you may be interested in extreme sports photography, so you would put together all of the portraits, all of the action shots, all of the location shots and so on from the different photographers under these headings. You could do this in a traditional sketchbook and create separate chapters or use a site such as Pinterest. Once you have created a specialization workbook it will be clear what kinds of photographs are relevant to your area of specialization and how important different genres of work are in creating a photographic practice appropriate for that area.

HOW SHOULD I SHOW MY WORK PROFESSIONALLY?

It's all very well taking photographs and talking about getting clients, but how do you show your work to these clients, and how do you get in touch with them? The answer to both questions is simple, but you have a number of choices open to you.

Rotate and update your work, be it on your website or in a portfolio. It should always be fresh.
Photographer: Jill Furmanovsky

The majority of professional photographers today will have three ways of showing their work to potential clients: a printed portfolio in a print box, a book or on a digital tablet. The printed portfolio is the most traditional way of showing work, so let's deal with this one first.

There are two forms of printed portfolio you should consider: The first is a print box containing a selection of your favorite images, well printed, all of the same size, well-spaced and protected by clear

plastic sleeves. This form of portfolio is the one I recommend most often, as it will not cost you too much and it is an excellent way of showing work that allows you to update your selection without incurring too much additional cost or trouble. You can purchase print boxes and the appropriate clear sleeves from good professional photographic supply retailers and online. They are not cheap, but they are a lot more affordable than a professionally produced portfolio book.

A professional portfolio is often referred to as a 'book' basically because that is what it is! (Don't be confused if someone asks to see your book, they mean your portfolio unless of course you have published a book!) Most are leather bound and consist of a high-quality, padded cover, usually in black (this is the industry standard, but there is no reason why you can't be more adventurous in your choice of color), filled with clear plastic sleeves that can be removed from a screw-mounted spine. These books are often custom designed and handmade, but they can also be bought readymade from custom portfolio makers, graphic supply stores and photographic supply retailers. Wherever you get one they are not cheap, and although you can shop around for a good price, the more you pay invariably the better the quality. If you have one of these books you will also need a custom bag to put it in, and this combined with the price of the sleeves comes to the kind of investment you might be more used to spending on a camera. So don't rush in to buying a book, but be aware that at some stage you will probably need to have one.

The third option to show work to clients in person is on a tablet. This obviously requires an investment in a tablet, but after that you have no further additional costs. The upside of showing work in this way is that back-lit images often look good, you are not reliant on the quality of your prints, they are easy to transport and you are showing your work in a way in which they may well be used. The downsides, however, are insurmountable: Many clients do not like looking at work digitally in person, yet some do. Therefore a purely digital presentation is a risk you have to decide whether you want to take. You

are reliant on getting a good wi-fi or mobile phone signal, and you are limited by the size at which your work will be seen. Despite the pros and cons I think that a tablet is well worth considering as a professional way in which to show a client your work, but you will need to have prints presented in a box or book as well.

CREATING A DUMMY PRINT PORTFOLIO

Before you order expensive photographic prints it is always a good idea to create a dummy portfolio of the images you are considering including. To do this first print out low resolution, low quality A4 prints of all of your portfolio images. Then lay them out on the floor in the order you are thinking of including them. When doing this you should begin and finish with your strongest images. Put these in position and then start placing the images between your start and finish point, taking into consideration subject themes, composition and image scale. Think of this as creating a conversation, in that it contains different levels of speech, punctuation and various points of emphasis. Your finished image order should feel like a well-constructed conversation. The order you have now decided upon is one that you should also use on your tablet presentation and website portfolio.

THE PROFESSIONAL PHOTOGRAPHY WEBSITE

Quite simply a website is your shop window; it is where you show people what you do and how you do it. Your photographic voice needs to be clear and confident before you create a website for your work. It is also the initial destination for your potential clients, so it is extremely important that the first page they land on, your homepage, does everything it needs to do. Think of your website in these terms and you will be well on your way to creating a successful homepage.

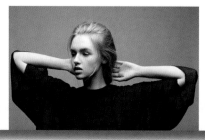

CHARLOTTE STEVENS Home | Portfolio | Collections | About

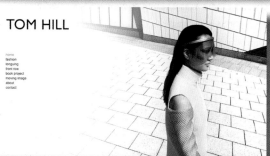

TOM HILL

home
fashion
tonguing
front row
book project
moving image
about
contact

All of these website homepages
demonstrate a clear specialization
of work, easy to navigate signage
and strong homepage images. They
demonstrate a professional approach
to photography across a wide
spread of photographic genres and
specializations.

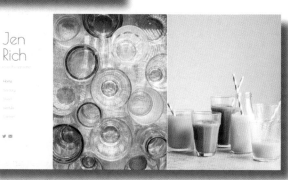

Jen
Rich

Home

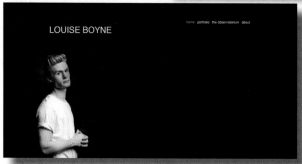

LOUISE BOYNE home portfolio the observatorium about

Liam Clarke Home Protfolio Projects About
Photography

The phrase "One picture or one minute" (that's all the time and opportunity you have to capture the client's attention with your work) is one I have heard repeated by countless photo editors, art directors, creative directors and, in fact, by anyone who commissions photography.

From a photographer's perspective, this approach may seem to be particularly harsh and ignorant, but it is one born of the realities of the world of commissioning professional photography today. Professional photography is a highly competitive business, and those in the position to commission are under pressure within an equally competitive high-pressure office environment. They don't have time to waste on websites that are overly complicated, hard to navigate or inappropriate to their photographic needs. You need both to understand and to respond to these factors when creating your website's homepage.

Choose an image that represents your work accurately, one that engages the viewer and encourages him or her to find out more about your work. Look for an image that has impact, that is memorable and that intrigues and informs the potential client about your work. Arguably, this image should be the strongest one from within your body of work—after all, it may be the only image your potential client chooses to see! There are no rules to what this image should be, but you need to ensure that it fulfills the commercial expectation you have for your site. If you want to be a shoe photographer, make sure it's a great shoe image; if you want to be an architectural photographer, make sure it shows what kind of an architectural photographer you are. These rules apply to whatever genre of work you are involved in.

CREATING A SUCCESSFUL WEBSITE HOMEPAGE

While there are no image-choice rules for your homepage, there are some simple rules to consider when it comes to your homepage's basic functionality:

1. Keep your menu as simple and direct as possible, and use industry-recognized terms to describe the sections you have created (such as portfolio, personal work, commissioned work).

2. Always have a 'Contact' tab that includes both your mobile telephone number and an email address connected to your website address. You should also include your social media platform tags here.

3. Include an 'About' section that explains who you have worked for, any relevant awards, publications or experiences and where you are based.

4. Ensure that you can click directly to any of these sections from the homepage. Avoid creating an additional landing page, which slows down the process of getting to your work. A landing page may cause only one additional click, but that extra click could lose you a commission.

5. Avoid creating too many additional sections and titling them with names or terms that you understand but which may require explanation to the uninformed.

A successful homepage has a strong and memorable visual identity combined with clear navigation and simple functionality. If you follow this simple formula, one picture or one minute will be enough to get the client you are looking for interested in the rest of your work!

Creating and launching a website when you are not ready to do so photographically can be a mistake. The moment you create one the world can see your work and you will be judged on that work, so my suggestion is to hold off with this for as long as possible. Use the energy that you would have spent creating the website in shooting more images and finding projects to work on. However, if you do want to begin the process of sharing your work and slowly building a community who likes your work, creating a visual blog is a great way to dip your toe in the water.

THE PHOTOGRAPHY BLOG

Let's be honest from the start: Creating a blog takes commitment, dedication and persistence. Without these applied qualities a blog founded on good intentions soon flounders after an initial burst of enthusiasm. So let's step back: As a photographer, are you trying to establish the right kind of blog? As visual artists we enjoy creating images, rarely writing words, so it makes little sense to establish a blog that requires extensive explanation and text. A blog should be fun to create and fun to view, inspirational to both you and to others. If you follow a few simple rules, a blog can also be a successful marketing tool for yourself as a young photographer. A visual diary blog can fulfill all of these criteria.

THE VISUAL DIARY BLOG

A visual diary blog is a blog of images you create that document your daily life and should provide a creative and informative backstory to you as a photographer. Remember:

1. A visual diary blog requires little text and can be compiled using any type of camera—including the one in your phone—you have at hand.

2. Simple-to-use, free blog platforms such as Tumblr or WordPress. com are easy to adapt and upload to from your desktop or from a mobile smart phone device.

3. Your subject matter and approach to your image creation should be defined by the life you lead and is limited only by your willingness and ability to see images in your everyday life experiences. Experimentation is essential in both photographic approach and subject matter, and your personal passions should be the driving force behind both.

A visual diary blog is meant to document your overall photographic vision, not to act as a portfolio of your best work. While creating your blog, try to lose your personal expectation of always creating a 'good' photograph. Instead, use your camera as a sketching tool, a means of loose image creation without too much thought. Don't delete images as soon as you have taken them; instead, spend each day capturing images, and use the end of the day to edit them. When editing, look for recurring visual themes, stories or subject matters that you can develop further. Once you have decided on your final edit of images, post only those that you feel are the most successful in showing your personal vision. Each day that you post your images, this personal vision should become more developed and defined. This will become clear not only to yourself but also to those interested in your work. This sense of progression should provide the inspiration and the required 'get up and go' not only to take more photographs, but also to persevere with your blog.

There are many examples of successful blogs for you to discover, but one that I always recommend to those starting out is *The Daily Chessum* created by New York-based photographer Jake Chessum. *The Daily Chessum* is a visually rich insight into the life and visual language of a successful photographer. Images captured on shoots are posted alongside outtakes from commissions and observational images that range from graphic observations to meals eaten—all of which support and reveal Chessum's personal visual language.

Only photograph what you love.
Photographer: Tim Walker

A visual diary blog can be a hugely rewarding and fun project to work on if you make sure that you set out to create something that is both achievable and relevant to who you are as a person and as a young photographer.

The Blogging No-Nos

1. Beware of making political statements.
2. Do not tell us what you had for breakfast or mention the weather.
3. Do not make jokes unless you are sure that you are funny.
4. Do not post sexually explicit content.
5. Do not bad mouth other photographers or clients.

CREATING AN ONLINE PERSONALITY

Although it is important that you have a way in which you can show people your work in person, you're most likely to have your work seen online. I have already spoken about the importance of having a professionally focused website, but there are many other ways in which you and your work can get noticed online. Social media is a very broad term for a range of different software platforms, many of which you are probably already using, but how you use them as a professional photographer will be very different from how you use them socially.

The use of social media in developing a photographic career is essential in the twenty-first century, and the most essential of all at the time of writing this book is Twitter. I say "at the time of writing

this book" as things change quickly in the digital world—only a few years ago MySpace was the place to go, but how many people even remember what that was today? Twitter can be whatever you want it to be, and you can use it however you wish, but here are a few tips on how to make it work for you as part of your photographic education.

TWITTER TIPS

1. The most important thing to understand about Twitter is that it is a rapid-form publishing platform. The moment you tweet you become a publisher, with the legal implications that brings with it. Think before you tweet! If you wouldn't say something to someone in person, don't say it about him or her on Twitter. You don't want to end up in court or with a legal letter arriving at your home.

2. It's just as important to remember that anything you tweet will stay with you online for many years. Future employers will be able to access your tweets, as will family members, so be polite and don't use it as a place to reveal your partying adventures!

3. On a more positive perspective, Twitter is a great place in which to find and develop your understanding of professional photography. If you see it as a place for digital word-of-mouth recommendations, you can discover photographers, exhibitions, specialist publishers, technical tips, photographic events and in fact everything that makes up the greater world of professional photography.

4. Start to follow the photographers whose work you admire and are inspired by and see whom they follow and who follows them. Spend some time researching these and decide whom you also want to follow.

5. Be social on social media! Don't jump in on other people's Twitter conversations, be respectful of others opinions and don't swear!

Photographers to Follow on Instagram
Initially those posting work on Instagram were looked down upon by professional photographers because of the over-reliance on pre-created effects and filters by many Instagrammers, but it is increasingly being taken seriously by international brands and professional photographers. Here are a few people to check out to get you started.

@pauloctavious: Chicago-based photographer Paul Octavious has worked with international brands such as Nike and *The New York Times*, and his images have a dreamlike quality to them. Worth checking out is his #samehilldifferentday series, capturing the ceremonies, people and natural changes that have transformed a simple mound of grass throughout the past few years.
@paridust: This is where art works meet fashion in simple graphic compositions.
@argonautphoto: Aaron Huey is a *National Geographic* photographer whose work focuses on the people and environments that make our planet. Each photo is accompanied by a story from Huey's travels or experiences and background on how he photographed the accompanying image.
@petesouza: Pete Souza is the Chief Official White House Photographer, who uses his Instagram feed to experiment with his photography and visual storytelling.
@inezvinoodh: Fashion photographers and husband and wife team Inez van Lamsweerde and Vinoodh Matadin have been at the forefront of creative image making for fashion clients including The Gap and Lady Gaga.
@cassblackbird: Cass Bird is a fashion photographer who brings her personal aesthetic into her commissioned work. Her Instagram feed is a pure reflection of her life and interests.
@zakshelhamer: If you're looking for great images of extreme sports shot across America this is the feed for you.
@rick_poon: Beautiful food, beautifully shot with a smart phone.

Of course Twitter is not the only social media platform that photographers use to communicate and share work with each other: Facebook, Instagram, Vimeo, Tumblr, WordPress and Flickr are all relevant, useful and, if used correctly, beneficial to the development of a photographer's career. When you are starting out you may lack confidence in the pictures you are taking, and the supportive communities these platforms contain can really help you start to understand your own work. However, not all comments will be positive, and you need to be strong enough to take the good with the bad when it comes to online comments from people you don't know and will never meet.

As someone said to me, Twitter is "a huge, massive, endless free flowing conversation with lots of interesting, witty people."
Photographer: Chris Floyd

Whatever platforms you choose to use you are in a fantastically positive position. You are all referred to by the industry as 'digital natives,' or people born since the invention of the Internet's global expansion. You have grown up with digital photography, stills, cameras and phones that make films, email, social media, downloads, podcasts, instant messaging and therefore do not need to learn new ways of communicating. You don't need to relearn a way of working, you just need to ensure that you embrace all of these opportunities open to you that you have grown up with and use them as educational and promotional tools for your photography.

PHOTOGRAPHY IS A BUSINESS

So far in this book I have focused on the creative and the personal aspects that come together to make someone a professional photographer. I've given you an idea of some of the elements involved that will help you turn your photography from a hobby or college project into a career. But there are some hard and fast facts you are also going to need to understand and implement if you want to protect yourself, your work and your client relationships as a commissionable professional photographer with the prospect of a

COMMISSION ESTIMATE

The Agency/Client :

Photographer's Name :

Photographer's Ref. No. :
Date :

The Advertiser/Client :

Job Description :

Media use/period of use/territory : ☐ Right to a Credit

Exclusivity period : Term of the licence plus _____ years (Subject to clause 5 of terms & conditions)

Fees :
Commission fee
Pre/post production fee
Other (specifiy)
Base Usage Rate _____

Total fees _____

Expenses :
Film, Processing
Prints
Location services
Travel
Subsistence
Production co-ordination/Assistants
Stylist
Make-up/Hair
Set build
Props/Wardrobe
Studio hire
Equipment hire
Models/Casting
Rush charges/Overtime
Special insurance
Messengers/Delivery
Miscellaneous

Total Expenses _____

Contingency _____ % of ESTIMATE TOTAL _____
Advance required before shoot commencement _____

Utilizing the correct paperwork when being commissioned ensures that you not only demonstrate a professional approach to your work but that you also protect yourself and the client from potential confusion over what is being requested and supplied. It also ensures that both parties are clear concerning potential costs. These documents have been adapted from those recommended and made available to download for free by the Association of Photographers in the United Kingdom, a service many national associations will be happy to provide.

long-term career. You might think that this is where what I have to say is boring and complicated. Hopefully it will be neither of these, and I will definitely make it as simple as possible to understand.

HOW MUCH SHOULD I CHARGE?

This is the question that most student and young photographers ask me, and there is no set answer. However, I do have a series of questions I suggest that you ask yourself and your potential client to try and come to a mutually acceptable solution.

1. Who is the person asking you to take the photographs, a friend, family member, family friend or someone you don't know who has contacted you on the strength of your work?
2. How are the photographs going to be used, for personal or commercial use? How often are they going to be used and where?
3. How much work is expected? How many images? What quality? How much time will you need to spend on creating the images and in post-producing the images?
4. Are you interested in taking the pictures you have been asked to take?
5. Have you been asked to take pictures like the ones you take?
6. What amount of money do you think is fair to be paid? How much would you be comfortable in being paid?

The answers to these questions will give you the answer to the bigger question, "How much should I charge?" By asking these questions you will not only show yourself as somebody who understands the business transaction of commissioning photography, you will also start to see if the person you are talking with is willing to pay you what you think is reasonable or anything at all! It is always

best to have these discussions before you agree to take any photo-graphs, as this conversation will quickly reveal the potential client as someone you want to work with or not!

There are no set rates in photography. The majority of professional photographers will charge a day rate, although some may charge by the hour, but I suggest that when you start out that you agree on an all-in-fee that ensures that you and the client know exactly what the shoot is going to cost. This cost and any other costs you are going to incur should be outlined clearly in a shoot estimate sent to the client prior to an agreement being made as to if you are going to take the photographs or not.

All photographers (as the author of an image) own the copyright to their images. So just as musicians can control who can repro-duce their music, photographers can control who can reproduce their images. Just because clients pay you to take photographs for them does not mean that they own those images. They don't! What they get for paying you to take them is a license to use them that you control. You can decide how long they are allowed to use your images, how often and where, not only where they are printed but also which countries they are used in. The more wide-ranging the license you give them the more the client will need to pay you for the license. However, the use of the images will be exclusive to the client. This means that you will not be able to allow anybody else to use the images during the time they are licensed and beyond, if this is agreed. You can use the images for your own personal pro-motion on your website, if you agree to this with the client; this is usually after the client has used the images at least once. It's quite simple really.

That is until clients say that they want to own the photographs and use them whenever, however and wherever they wish without having to pay you after the initial payment for creation. This is when you would decide whether or not you want to give the client an unlim-ited license that includes every possible media, including billboards,

videos, TV, CDs, T-shirts and so on, for worldwide use for the term of copyright (seventy years after the photographer dies). The price for this type of license would be enormous, and the client may well be paying for use that the client does not need.

So to avoid this more and more, clients are asking photographers to sign what are referred to as 'All Rights' contracts. These have

LICENCE TO USE

Granted to (Agency/Client): Photographer's Name :

 Photographer's Ref. No. :
 Date :
 Art order No :
The Advertiser (Client) :

Description of photograph/s covered by the licence:

Terms of the licence :

Media Use

☐ Artist reference ☐ Packaging
☐ Brochure ☐ Point of sale
☐ Catalogue ☐ Poster (less than 10sq metres)
☐ Inserts ☐ Poster (more than 10sq metres)
☐ Magazine consumer ☐ Television/Cinema
☐ Magazine trade ☐ Test
☐ National press ☐ Other (specify) : _____

Territory :

☐ UK ☐ English language areas
☐ Single EC Country ☐ Worldwide
☐ Continental Europe ☐ Other (specify) :
☐ USA

Time Period

One year
Two years
Other (specify) : _____

Right to a credit ☐

Exclusivity Clause

I confirm that I shall not publish or supply the material to any other person for
publication during the term of the licence plus _____ years, without the express permission of the
Agency or the Advertiser.

I confirm that the Agency and the Advertiser are hereby licensed to reproduce and publish the
Photographs, for the above purposes

Signed : Date:

The use of images and international copyright can be confusing so to keep things simple make sure you issue your client with an easy to understand license to use.

the same effect as the unlimited license but cost the client no more than the payment for commission. As you can imagine this is a controversial development for many professional photographers, but it is a practice that the majority of large editorial publishing companies have implemented, so the chances are that it is something that you will come across. You can and should try to negotiate to keep your copyright/ownership of your images, but when you are starting out you may find your success in this limited. Sadly, the decision you will have to make is simple: Do I want to work for them and hand over my copyright for no extra fee, or not work for them?

WHY YOU SHOULDN'T LOSE YOUR COPYRIGHT

- **You will lose control of how and where your images are used.**
- **The client can sell/license your work to a third party.**
- **If the company closes, your images become an asset in the liquidation of that company.**
- **If the company is sold, your images go with them to be used by others.**
- **The fee you receive will not be appropriate with the use the client may get.**

HOW/WHAT SHOULD YOU NEGOTIATE

- **Explain that you do not assign copyright and that you license your work.**
- **Also explain that they do not need copyright, they need an exclusive license to use.**
- **They do not need all media, worldwide, in perpetuity.**
- **The cost of all the usage a total rights assignment gives is extremely high.**

1. There was no 'copyright' logo or any other watermark on the photograph. Copyrights exist automatically, and as soon as an amateur or professional photographer (or anyone else, for that matter) creates a photograph they have created a copyrighted image. Therefore, a photographer does not have to specify on the photo or on his or her website that the photo is protected by copyright. Unless specified otherwise, everyone should consider a photograph on or offline to be copyrighted.
2. The photo was on the Internet therefore I can use it for free! Is a photograph easy to copy and download when it's on the Internet? Yes. Does a photo lose its copyright status when it's uploaded onto the Internet? No. The photographer keeps his or her copyright and, depending on the country the photographer lives in, his or her photo will remain copyrighted between fifty to seventy years after his or her death. Only after those periods will it be available from the public domain for people to use however they wish.
3. I found it on Google Images, and I can use their images for free, however I wish! Google Images is not a free stock photo agency, and they do not own any of the photos shown as a result of your search; the photographer who created the images or the companies

who commissioned them own the photos and the copyrights.

4. It was on Facebook, and everything on Facebook is free to use! Contrary to popular belief, a photographer does not lose his or her copyright when a photo is uploaded on Facebook. Images on Facebook can only be shared by another user by using the 'share' button and only if the photographer allows this to happen by choosing as much on the privacy setting. You are not allowed to save any photographs from Facebook on your computer or use them anywhere else on Facebook or on the Internet.

5. I used the photograph, but I won't make any money from using it! Whether you make money or not makes no difference to the laws of copyright.

6. I wrote the photographer's name under the photo, which gives the photographer and his or her work free promotion! Only the owner of the copyright can decide how the photo will be used. Promotion for the photographer is not a valid nor a legal reason to use a photo without first asking the photographer, especially since it is a legal requirement in most countries that the photographer's name is placed near a photo, even when the photographer has been paid for the license to use it.

7. Everyone does it! This is never an argument that is going to hold up in any court of law.

- **Ask them exactly where they need to use the work so that you can price the job fairly.**
- **Offer an exclusive license (this allows the client to control the work during a negotiated term).**

HOW CAN I STOP PEOPLE FROM STEALING MY IMAGES?

The idea of someone wanting to steal your images may be a strange one to you. You may even be flattered by the idea that someone likes your photographs enough that they want to use them without your knowledge. But for professional photographers the illegal use of their images is no different than stealing from a store. Prior to digital photography and the growth of the Internet it was not an issue that a photographer had to deal with, but today it is a rapidly growing problem that every photographer has to be aware of and attempt to prevent.

So how can you prevent people from stealing your images? Well, there are a number of options open to you at different stages. First, when you are taking your photographs you can ensure that you are embedding the appropriate metadata. Metadata is the information that is attached to every individual photo file that gives you the technical data about the camera settings when you took the picture, but it can also be information about where, when and who took the picture. To do this you can either adjust the information settings in-camera on some models of camera or use a post-production software package to input the information. Whichever you do, this is an essential first step in protecting your images. Why? Because metadata allows you to track your images online and to prove that the image is yours!

You may have heard of the term 'watermarking' as a commonly used way in which to protect your images, and there is no doubt that it

is something you should consider. Many photographers would not dream of putting an image online without one large or a series of smaller watermarks on their images. The watermark either features the photographer's name or logo across the image in an opaque color, thus preventing anyone from using the image commercially. It is an effective solution, but not one that works for images being placed on a website to show potential clients, who want to judge the quality of your work not your watermark.

Another way of ensuring that people have limited options as to what they can do with your images stolen online is to upload them at a size that prevents offline usage. The right size to post your images online is 72 dpi with no side being longer than 1024 pixels. This is big enough to ensure good quality files for online viewing but not big enough for offline printing.

You will have to accept that the chances of your images being used by others for a variety of different reasons without your knowledge is probably going to happen at some point, but the processes I have outlined will help restrict this illegal use of your images.

HOW TO UNDERSTAND A CONTRACT

A contract is an agreement between two parties and is a legal document binding on both parties. Many contracts issued by clients are long and complicated to understand, while others are short and to the point. Most of them will contain terms that you are expected to agree to but which are not in your best interests. Contrary to popular belief, it is not illegal for a contract to ask for an assignment of copyright, as contract law overrides copyright law. If you and the client agree to the terms of a contract, then it stands.

In general, the last set of terms and conditions received before the shoot are the ones that are binding, so it is very important that you

read all of the paperwork the client gives you and that you question any areas that you are not happy with, or do not understand, *before* you start the shoot, and don't forget that any amendments you want made to the contract, and that are agreed upon, *must* be in writing (an email is fine).

When talking to your clients, be aware that they didn't write their companies' terms and conditions, their lawyers did. Lawyers have to look after their clients' interests, so they often write contracts in which everything gets thrown in, just in case! Your contact/client may never have read the terms of the contract but will have been instructed to send it out for each commission. Be aware of this and deal with the client firmly but politely at all times.

All contracts will have some form of clause, which asks you to indemnify (excuse from liability) the client from claims that may occur from the publication of your photographs, and requiring you to guarantee that you are the holder of all of the rights in the photographs. Basically, this means if anything goes wrong you are to blame and will have to deal and pay for any solution to those problems that needs to be met. For example, you may be expected to own the rights to everything within the image, as well as your own copyright, from models, locations, third-party copyright, trademarks and any other property rights together with privacy and personal rights, which may exist in other countries. This is complicated and unrealistic, so this is why you should not agree to this in any contract.

1. **Even a lawyer cannot be expected to know the laws in all countries.**
2. **You are being forced to guarantee circumstances and be liable for consequences that are out of your control.**
3. **You will be liable if the commissioned work is found to be infringing somebody else's rights, and you may have to defend yourself legally, while possibly having to pay your client's legal costs and any settlement that is reached with the claimant.**

GET COVERED AND PROTECTED

As a professional photographer you will be expected to have a selection of insurance policies to protect yourself, your equipment and the people you are photographing in place before you are commissioned. These policies will cost you to take out, but as the name implies they are an insurance not against things going wrong (such as people taking action against you even though you have followed correct professional and/or legal procedures) but against those actions causing you further problems in the future. The most important types of insurance you need to take out are:

1. Public Liability Insurance: This type of insurance would cover you if a client, model or member of the public was to suffer a loss or injury as a result of your photographic activities and if that person made a claim for compensation. The insurance would cover the compensation payment plus any legal expenses. Even if you do everything correctly there is always the chance of an accident happening. With this insurance cover, you can work knowing that should the worst happen, any property damaged could be repaired, possessions replaced and medical costs paid for. Any business that has visitors to its premises or involves work on location needs public liability insurance. You may be asked to present your insurance schedule and documentation before being commissioned, particularly if the shoot is on location and could be considered to have a dangerous aspect to it.

2. Professional Indemnity Insurance: This is an insurance that will protect you if you are alleged to have provided inadequate advice, services or photographs to a client. Professional indemnity insurance provides cover for the legal costs and expenses in defending a claim against you for any of these reasons, as well as paying

compensation payable to your client to rectify any mistake. Regardless of how many years' experience you may have, there is always the possibility you (or one of your team on a shoot) could make a mistake. Professional indemnity insurance covers against a wide range of possible issues, including: making a mistake in a piece of work for a client; loss of documents or data (such as losing or corrupting digital image files); unintentional breach of copyright and/ or confidentiality; and defamation and libel (saying or doing something that could be considered as being inappropriate and detrimental).

3. Employers' Liability Insurance: Now this is a serious one, and certainly in the United Kingdom a legal requirement if you employ anyone. Now this may seem like a long way off from where you are at the beginning of your career, but as soon as you pay an assistant, stylist or hair and make-up artist you become an employer. So if you are based in the United Kingdom you must take out Employers' Liability (EL) insurance as soon as you become an employer, and your policy must cover you for at least £5 million. EL insurance will help you pay compensation if an employee is injured or becomes ill because of the work he or she does for you. You may not need EL insurance if you only employ a family member or someone who is based abroad, but it is worth checking with an insurance company as you can be fined £2,500 for every day you are not properly insured, and you can also be fined £1,000 if you do not make it available to an inspector if you were ever to be asked for it. If you are not based in the United Kingdom, make sure you find out what your national government requirements are with regard to this type of insurance cover.

4. Photographic Equipment Insurance: Professional photographers need the right equipment to do the job

they are being asked to do, and that equipment can often be expensive. It is also the nature of photography that you are going to use that equipment in all sorts of locations and situations—most of which puts that equipment into a position in which it could get damaged, lost or stolen. You therefore need to ensure that you have insurance cover for all of your equipment that is annually reviewed and updated. You can get this type of insurance from a general policy insurance company or add it to your parents' house contents policy. If you do this, make sure that you give the company the full details of the equipment you have to ensure they understand its importance to you and its true value. You could also use a specialist photographic equipment insurer for this and a number of the other insurances you will need.

Always buy the very best equipment you can afford.
Photographer: Terry O'Neill

HOW DO I DELIVER MY WORK TO A CLIENT?

This is not a book that deals with the technical aspects of photography in any great detail; there are many other books you can read and places you can go to online that will give you that information. However, there is one element of digital capture that I need to mention at this point. As I have mentioned previously I like to keep things simple, and that is also how I like to deal with the subject of shooting RAW and JPEG files—simply!

This is my simple explanation of why you need to shoot both RAW and JPEG for you and your client. First let's think about music: the best and most realistic sound you will hear of a band is when you

hear the band playing live in person; the next best would be a vinyl record, because the sound information has suffered very little compression in being made into a record. The next best would be a CD, where the sound has been compressed more than a record to make it fit on the disc, but not as much as a download, which is the most compressed version of the original recording. Why is compression a bad thing? Because each time the information is compressed some of it is lost. Therefore you have lost some of the original recording that made it sound so special when played live.

A digital photographic file works on the same basis: the RAW file is the vinyl record; the high-quality JPEG is the CD; and the low-quality JPEG is the download. That's why you should always shoot RAW files, because RAW is the most accurate version of what you see that will allow you to work with the most information possible if you choose to do any post-production on the file. The reason why you should also shoot JPEG is led by the client's requirements. Most professional DSLR cameras will allow you to shoot both at the same time, so that is what you should do and this is why.

I try not to restrict my commissioning to the tried and trusted; I enjoy taking chances with young photographers, as the results can be exciting and surprising.
Photographic director, *Telegraph Magazine*, UK: Cheryl Newman

A SIMPLE CLIENT DELIVERY WORKFLOW

1. Shoot RAW and medium- to high-quality smooth JPEG.

2. Use multiple memory cards throughout your shoot. Download each card to your laptop and to an external hard drive on the shoot. *Never* use just one card on a shoot. *Never* use memory sticks for back up. *Never* leave a shoot without backing up all of your work.

3. Create a specific folder clearly titled with the name of the shoot containing all of the files from the shoot. Burn the folder onto a DVD and store them onto an external hard drive. You should never have less than three copies of any shoot. It is also a good idea to store one of these versions in a safe place not in your own house.

4. Once you have a shoot folder, create three folders within the master folder. Title them RAW, JPEGs and EDIT. You should then put all of the RAW files into the appropriate folder and the JPEGs in their folder. Now open the JPEG folder and use these files to edit your shoot. You can do this by using a star-rating system within a software package such as Lightroom or Photoshop or by dragging your chosen files directly into your EDIT folder. Whichever way you choose to work, your EDIT folder should contain only the images you want to send to a client. The number you choose will vary from shoot to shoot and client to client, but approximately six to ten images from each set-up should be about right.

5. Once you have an EDIT folder of images you are happy with, you need to send these *only* to the client. The best and easiest way to do this is via a software transfer platform such as WeTransfer or Dropbox. Some clients may have an FTP (file transfer protocol) network, which you can drop your images onto; these are easy to use, and you will be given a password and account details to allow you to do this.

6. The client will then use the JPEGs to choose the final images to use and how. Once the client has made a decision, you will be contacted for

the high-resolution files. It is at this point that you turn to your RAW file folder. Because you shot both RAW and JPEG files simultaneously, the JPEG files you submitted to your client will have the same file number as the RAW files, so they will be easy to find and there will be no confusion over which file has been chosen.

7. You need to supply your client with an 8-bit TIFF RGB file, and this is created from your RAW file. You can use your camera's dedicated software to do this, or a post-production software package. My suggestion is that you do this in two stages. First create a 16-bit TIFF and use this for your post-production work. Once you have finished working on the file then convert it into an 8-bit TIFF file that is 300 dpi and approximately A4 (210mm x 297mm) in size for general print usage. This file is the file you then deliver to the client in exactly the same way you delivered the JPEGs. Never send these via email, as the files are too large and will only block up and fill up your client's email inbox. You may also be asked by the client for a 'match proof'; this is a print of the digital file you have sent them that will be used to match colors to when the image is being printed commercially. If you are asked for one of these, be sure that you submit a professionally printed photographic print from a specialist printer, and charge the client for the costs you incur in having it made.

8. You should never supply TIFF files or any file converted to CMYK (cyan, magenta, yellow, key/black) unless specifically asked to do so. The reason for this is that CMYK conversions are linked to commercial printing profiles, and every one of these is different! As you don't know what profile is going to be used, it is always best to let your client convert your RGB (Red, Green and Blue) film to CMYK. If you are asked to supply CMYK files for print, make sure you know which profile to use.

9. You should then create a TIFF folder in your master shoot folder and drop your TIFFs into this folder. Then burn the folder again onto a DVD and place it onto an external hard drive as your archive copy.

10. That's it! Work delivered, archive created and all the way through the process you had your backups on hand if required.

HOW DO I GET PAID AND HOW DO I INVOICE?

Now it's time for the best bit. It's time to get paid, and the way that you start the wheels in motion for this to happen is by sending your

COMMISSION INVOICE	
The Agency/Client :	Photographer's Name :
	Photographer's Ref. No. :
	Date :
The Advertiser/Client :	Product :
Job Description :	
Media use/period of use/territory :	

Fees :
Commission fee _____
Pre/post production fee _____
Other (specifiy) _____

Total fees _____

Expenses :
Film, Processing _____
Prints _____
Location services _____
Travel _____
Subsistence _____
Production co-ordination/Assistants _____
Stylist _____
Make-up/Hair _____
Set build _____
Props/Wardrobe _____
Studio hire _____
Equipment hire _____
Models/Casting _____
Rush charges/Overtime _____
Special insurance _____
Messengers/Delivery _____
Miscellaneous _____

Total Expenses _____

TOTAL COST _____
Less Advance Paid _____
TOTAL AMOUNT DUE _____

Once you have completed your commission you are going to want to be paid, so make sure you send a professional invoice containing all of the relevant information to the client.

client an invoice. This is an easy and simple process that once it is set up is easy to replicate. First, you create an invoice similar to the one on the facing page.

Once you've sent the invoice it's time to be patient! Unfortunately, it is rare these days to find a client who will pay you quickly. Hopefully, most will pay you within a reasonable amount of time or preferably within your stipulated time for payment, but many will not. If this is the case, then you need to begin by politely sending a reminder email to the person who commissioned you. If this gets little response, follow up the email with a similarly polite phone call. If this doesn't work, then try to speak very politely with the client's accounts company. However, do not do any of this until after your time for payment (this is usually thirty days after the shoot date) has passed. A good tip to help you with this is to date your invoice to the date of the shoot and use the term 'calendar' rather than 'working' days to ensure you do not give the client the opportunity of extending the thirty-day period.

Of course there is always the possibility that you will not get paid at all (this happens to even the most experienced professionals). If this does happen, then you will be left with no alternative other than to seek legal advice. Don't be afraid of this, as it is often easy to do and does not have to incur large expense.

Photography is essential to all businesses that need to sell some-thing, whether that be a product, a service or a message, but it is a business in itself, and I hope that you now have an understanding of that business, how you can fit into it and what you need to do to succeed. But never forget that no matter how good a businessper-son you are in professional photography, it is always all about the images, and that is what you most focus on.

CHAPTER 5

GOING IT ALONE, AND WHERE DO YOU FIT?

THE MAJORITY OF PROFESSIONAL photographers work on what is referred to as a freelance basis. This means that they have no guaranteed monthly income and no single employer. There are full-time roles for photographers within some publishing companies and large retail brands, but these have a tendency to be limited in creativity and in opportunities to progress and evolve your work. This is not always the case, but it is worth bearing in mind if you are the sort of person who is either looking for a 'secure' job or creative freedom.

Over the last few years the traditional role of the contracted newspaper photographer has also started to disappear, moving these photographers into the freelance environment. This reduction in 'staff' jobs has forced a lot of photographers to reconsider the way in which they work, but has also bought some great photographers into an already competitive freelance environment. It is this word 'competitive' that you will hear most often when people talk about the challenge of working as a professional photographer, but it is not a word that you should be scared of—just be aware of the challenge you are taking on.

A career is a whole lifetime. Learn your craft and keep working at it—it takes hard work. Have fun. Enjoy the day. Enjoy the work.
Photographer: Robin Broadbent

As a freelance photographer you are primarily going to be working on your own. Creating your personal work, building a website, dealing with your social media, creating your stationery, contacting clients, meeting clients, constructing budgets, sourcing locations, assistants and props are just a few of the tasks you will have to complete alongside taking photographs. Now I know that this may come as a surprise to some of you reading this, but don't be put off. It is rare that you will be doing this all at the same time, and all of it can be achieved by creating a well-ordered work process and photographic

practice. The most important thing when you are starting out is to understand that you will need to do these things, and they will not be an option.

You may have noticed in this that I have not listed any photographic equipment; there are a number of reasons for this. First, because every genre of photography requires different combinations of kit, and second because it is possible to rent the kit you need for a specific shoot and charge that rental to the client or include it in your fee. Owning an expensive photographic kit is not going to make you a professional photographer, whereas if you do everything I have outlined you will have the basis of what you need to build your career.

All of these elements are relevant to all genres of photographic specialization, but each area also has its own specific requirements and process of client engagement. It is obviously essential that you understand these, so I have broken down the main areas of photographic practice and listed what you need to know. There are always variations in how people work, but these will give you the basic information you will need to get started.

What Does a Freelance Pro Photographer Need?

A website
Personalized stationery, including letterhead, invoice and business cards
A digital and printed portfolio
Appropriate insurances
Marketing material such as postcards, self-published books
Social media accounts including Twitter and Facebook
An email address connected to your website such as contact@......com
A good telephone manner

> *I started being a photographer because I liked fashion. I liked the idea of dressing up and changing my look. I got earrings, dyed my hair. I would dress like a fashion photo.*
> Photographer: Mario Testino

WHAT DOES IT TAKE TO BE A FASHION PHOTOGRAPHER?

When I ask students what kind of photographs they want to take, eight out of ten will say 'fashion', and the remaining two will say that

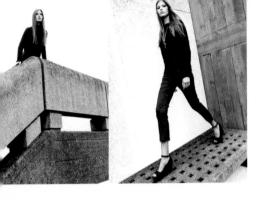
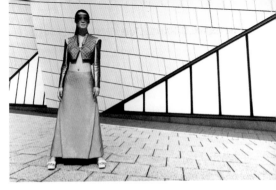
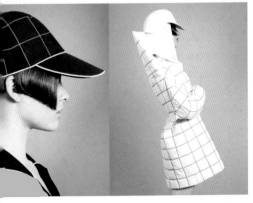
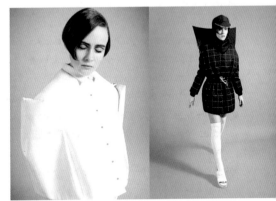
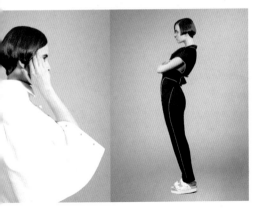

These fashion images created by photographer Tom Hill demonstrate the importance of allowing the clothes to lead aesthetic decisions concerning location, styling, photographic approach and creative narrative.

they don't want to do fashion because they can't do it. In response to this I always ask the same questions. If you are thinking of working as a fashion photographer, you should answer those same questions before you read any further. Here they are: Does fashion really, really matter to you? Do you follow the catwalk collections? Are you aware of stylists and fashion editors' work, as well as fashion photographers? Can you name the leading hair and make-up artists? If not, then don't consider it as an option. To be a fashion photographer, you really have to understand clothes and love fashion. It has to matter to you!

Most of the students I ask these questions of have not realized what fashion photography is or demands of the photographer. So don't worry if that is your response; it may be an unwelcome realization, but better to have it now rather than after you have invested too much time and effort in the wrong direction. Fashion photography is created to sell clothes, pure and simple! And the fashion industry is a big business that requires fashion photographers to understand this and work to achieve these aims. Magazines understand this and will expect you to as well, while you bring creative and innovative ways to create contemporary fashion images. Simple, really!

Well, yes and no. This is either going to work for you or it isn't—there is little space for half measures in fashion photography. To further illustrate this, here is how a fashion shoot commission happens for a magazine:

1. You will get a phone call from a fashion editor saying that they have seen your work on a website or elsewhere and would like you to shoot a story for the magazine.
2. If you have not met each other you will be expected to go and see them to discuss the shoot.
3. At the meeting you will be told what the fashion story will be. This will be based on trends that are dominant from the most recent catwalk shows and/or on the high street. You will be told where the editor is thinking of shooting the story, the aesthetic approach and which models have been 'optioned' (this is the term used for a model booking). They will show you images of all of these, the models and the locations, if they have them, and explain that the magazine wants you to do the story because they think that your work fits their ideas.
4. You will discuss their ideas, and there will be space for some input but don't expect much. You will be asked if you have your own hair and make-up people: if you do, they may be accepted; if not, others will be suggested that the editor thinks are good. You may get to look at

the clothes, but most probably you will see them in what is called a 'lookbook' (a book created by the clothes designer or retailer featuring that season's looks). You will not get to choose which clothes you shoot or how they are put together.

5. If you agree to do the shoot, you will be sent a shoot schedule and be expected to shoot the story you have discussed and as it was discussed, working with the editor and the team on the shoot. Don't forget that the fashion editors will have told their bosses, the magazine's editor and the magazine's art director, what they are going to do, so they will expect you not to let them down. Their job is on the line as is yours!

6. You submit an edit of images of each outfit shot after the shoot (this will usually be a minimum of six outfits in a day), and the fashion editor, editor and art director will decide which of your images are used and how. Again, you may have some input at this stage, but do not expect any. You will then be paid your expenses on the basis of the agreed shoot budget, and a page rate on the basis of how many pages your images appear on.

Check These Fashion Photographers Out

Nick Knight
Guy Bourdin
Willy Vanderperre
Mert Alas and Marcus Piggott
Mario Sorrenti
Steven Meisel
Bruce Weber
Carter Smith
Solve Sundsbo
Cass Bird
Steven Klien
Mario Testino
Paolo Roversi
Peter Lindbergh
Tim Walker
Craig McDean
Josh Olins
David Sims
Arthur Elgort
Ben Watts
Norman Parkinson

Three rules of success in fashion: Perseverance, dream a bit and be passionate about it.
Creative Director, *Vogue* (US): Grace Coddington

That's how it works in the editorial environment, and as you can imagine the advertising environment is even more structured. However, fashion photography has the possibility of being brilliantly creative, imaginative and cutting-edge. It can involve travel, incredible life experiences and good pay. You just have to be really committed, work really hard, be extremely good at networking and know the fashion industry inside and out.

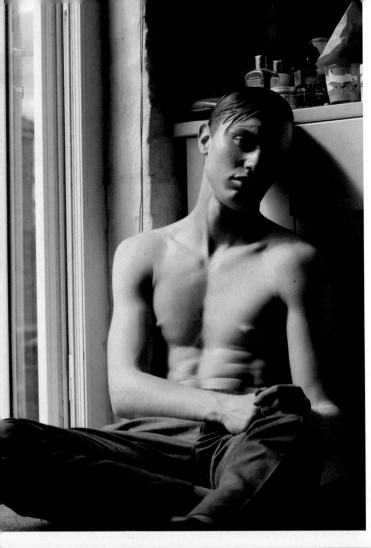

Men's fashion photography is just as important an area of the genre of fashion photography as women's, but it is often less directly led by clothing. These two graphic images by photographer Ben Breading demonstrate how flexible men's fashion photography can be in its approach and implementation.

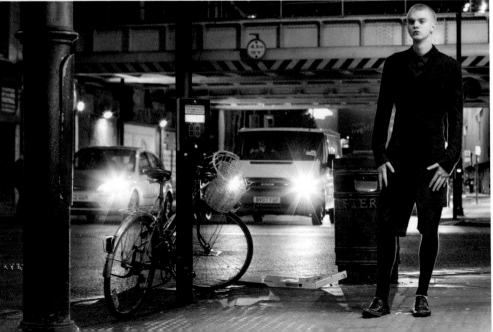

CREATE A SIMPLE FASHION SHOOT

When starting to shoot fashion you have to understand that you do not have access to the world's most beautiful clothes, best models or creative hair and make-up artists, therefore you have to work with what you've got and what you can afford. Here is a brief that helps you overcome these issues and allows you to concentrate on the essential elements of fashion photography—the clothes, the attitude and the narrative.

1. Go to a charity shop or flea market and buy six cheap, plain, simple white shirts that have slight design differences between them.

2. Find a friend, male or female, to be your model for the shoot, and source a location that you think will be interesting to photograph them in (please avoid clichés such as walls covered in graffiti, deserted factories and broken-down houses). Look to your image scrapbook for location inspiration.

3. Avoid obvious hair and make-up and keep your model looking natural. Do not work with a team on your first shoots: you need to learn how to communicate with your model, and that is easier to do when there is just the two of you.

4. Shoot each shirt on the model, each time changing the location or background. By the end of the day you must have a minimum of six different sets of images, one set for each shirt. Each set should contain the model photographed full length and from the waist up in portrait format.

5. Shoot, shoot, shoot! When you start out you cannot shoot enough frames. Move around the model, try different angles and compositions and most importantly make sure both you and the model have fun.

6. Edit the most successful images from each set, and then look to put them into pairs. This is how fashion editorials will appear, so it is important to learn how to shoot not only successful single images but also images that will complement each other within the overall narrative.

You don't create a photo: you find it. And I still do that.
I follow my instinct and my intuition and I respond to
the moment, the decisive moment.
Photographer: Sante D'Orazio

WHAT DOES IT TAKE TO BE A PORTRAIT PHOTOGRAPHER?

To be a fashion photographer you have to have a passion for fashion. To be a portrait photographer you have to have a passion for people. You have to love meeting new people, talking to them, finding out about them, and be interested in what they do and why they do it. You have to be inquisitive, a little bit nosey and a very good listener.

I am always stimulated by people. Almost never
by ideas.
Photographer: Richard Avedon

Just as fashion photography can be studio- or location-based, portrait photography can take place in a wide range of different places and be approached in a myriad of different ways. The art of portrait photography goes right back to the earliest days of photography, and in many ways it is the type of photography we spend most of our time looking at—from family snapshots to 'selfies' to styled celebrity portraits, portrait photography embraces them all.

I always say that a good portrait image is the proof of a good conversation. The second leads to the first and gives the photographer the insight needed to create a photograph that is more than what somebody looks like and is instead a representation of what the subject thinks and feels. This is the aim for the majority of the purest

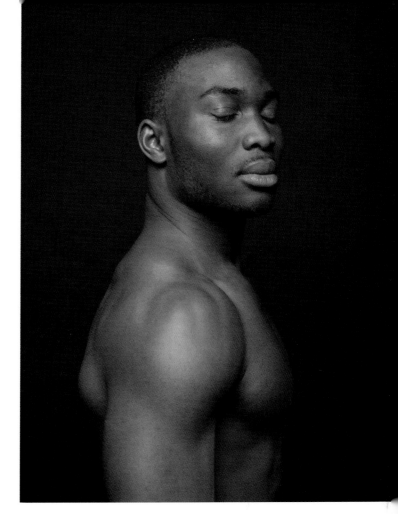

This powerful image by photographer Joanna Hodson illustrates the purest form of portrait photography in which the documentation of the subject is the central focus of the image.

portrait photographers, such as the greats like Richard Avedon, Karsh of Ottawa and Irving Penn. However, portrait photography also embraces conceptual approaches to image making, as seen in the work of photographers such as David LaChapelle, Chuck Close and Annie Leibovitz. It also incorporates less formal and more environmental approaches, such as in the work of William Klein, Garry Winogrand, Bruce Gilden and Ryan McGinley. Portrait photography, the photography of people, infiltrates nearly all forms of professional photography, but from a commissioning perspective it has to meet a client's brief, however loose that brief may be.

The tools I learned photographing celebrities, now I want to use them to sell ideas.
Photographer: David LaChapelle

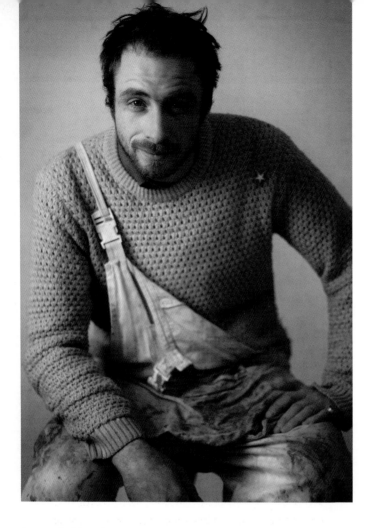

Unlike photographer Ben Breading's fashion work, this simple and direct portrait uses only the personality of the sitter to draw us into the image.

Just as fashion photography has a template for commissioning, portrait photography within a commercial perspective has a pattern of commissioning that I can outline for you:

1. You will get a phone call or email asking if you are free on a certain date for a shoot, usually within the following week if not in the next few days. If it is an advertising job, you will probably get more advanced warning of the shoot date.

2. If it is an editorial shoot, you will be told whom you are being asked to photograph, why and where. The reason will usually be associated with a product launch (such as a book or album launch) or event (such as a play or film opening), and the where will either be on a location connected with the reason for the shoot, the subject's home or in a studio. If it is an advertising shoot, expect to

begin a process of client meetings and extensive briefing, including mock-ups of exactly what they want the finished shot to look like. If it is an editorial shoot, you can expect to receive a client brief and/or a shoot schedule—or nothing at all! If you have been asked to shoot a celebrity, then the budget will be in line with the 'importance' of that celebrity, so expect to be working with a stylist and hair and make-up artist. If your subjects are, as I call many of the people I shoot, "people you may have heard of." don't expect a budget to cover anything more than yourself and possibly an assistant. Of course, an advertising budget should be enough to cover you to do everything you need.

3. Either way, you will be expected to instantly get on with the person you are shooting the moment you meet, and to have done your research so that you can engage in informed conversation. Don't expect more than fifteen minutes to get your shot, and the quicker and more efficiently you work the more you will be appreciated on the shoot by all concerned. A good tip to make this happen is to arrive at the shoot location early and to decide where you want the shoot to take place before the subject arrives. Decide on your lighting set-up if you are using one, and shoot the portrait using a stand-in. That way you can direct your subject and inform him or her of your idea without delay after you have met. To cover yourself, make sure you have tested more than one option in case the subject does not like your first idea. It is also always a good idea to give your client 'options.'

4. Always go to a shoot with an idea of what you are going to do, but always be open to this idea changing or developing through interaction with your subject. Communicate your ideas clearly to your subject, and make him or her feel involved in the process.

5. After the shoot you will be expected to supply an edit of the images you have shot, ensuring that you have met any brief you have been given.

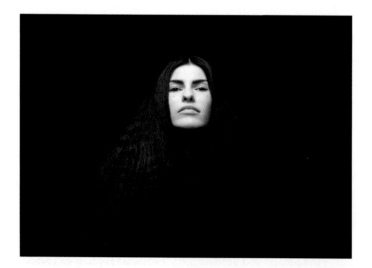

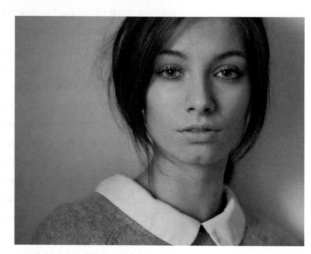

Two very different approaches to creating a portrait are illustrated here by photographers Charlotte Stevens and Joanna Hodson. Stevens' approach is strong and extremely graphic in its composition and lighting, using the subject's hair to provide the context for the composition; as such it is a strong portrait of the subject but could also be used as an image within the professional genre of hair photography. Hodson's portrait is far softer and has a fragile quality that may well reflect the subject's personality. Again, it is a successful portrait of the subject, but it is also one that could sit comfortably within a fashion narrative.

As I have mentioned, portrait photography crosses into many areas of photography—music, sports, food, fashion, documentary and interiors/lifestyle photographers among others all shoot portraits as part of their commissions. But if you see this as an area of specialization that works for you, then make sure you shoot as many of the people you know as possible, and then everyone you find interesting looking or who has interesting personalities or life experiences. All

areas of photography require constant shooting to improve the work you create, but portrait photography also requires you to develop your social confidence and interpersonal communication skills as well. This you can only do by being one-on-one with your subjects again and again, until both your photographic and social confidence become developed enough to let you take the kind of photographs you want to take.

WHAT IS STYLED PORTRAITURE?

If you thought you wanted to work within fashion photography but couldn't honestly say that you have the required passion for fashion, styled portraiture could be an area for you to consider. You might also hear styled portraiture described as celebrity portraiture, as most portraits of celebrities are styled, but what do I mean by 'styled'? Simple, really; it just means that the portraits are styled by a stylist who will have brought a selection of clothes to the shoot for the subject to wear. The emphasis on the shoot will not be on the clothes, but the clothes will inform the shoot. What I mean by this is that the purpose of the shoot is not primarily to sell the clothes, but the celebrity being photographed wearing them is an advertisement in itself. Many celebrities have contracts with particular designers and therefore will only wear that designer's clothes on shoots; others will be more open to experimenting with clothes chosen to work well in photographs that they wouldn't wear every day. It is not unheard of for a celebrity to ask to keep the clothes at the end of the shoot, which can often cause an awkward moment for the stylists to deal with, but that will be their problem not yours!

A good photographer is always actively seeking to progress themselves and develop their process—questioning is their most important quality.
Make-up artist: Alex Box

This styled portrait by photographer Louise Boyne was commissioned by a band to be used for marketing purposes. Although the lead singer is photographed mainly in his own clothes, in this image the addition of the flag and the overall feeling of the image makes it one that could comfortably sit within a fashion narrative.

Check These Portrait Photographers Out

Richard Avedon
Chuck Close
Irving Penn
David Bailey
William Klein
Annie Leibovitz
Franck Ockenfels III
David LaChapelle
Karsh
Platon
Jake Chessum
Jim Fiscus
August Sander
Nadav Kander
Chris Buck

Styled portraiture allows you to create images using the latest fashions and work with fashion editors and stylists without having to create a fashion narrative. Although it is work that many fashion photographers do, it can also be a great way for portrait photographers to dip their toes into the fashion world.

A SIMPLE PORTRAIT BRIEF

If you feel overwhelmed by the options available to you as a portrait photographer, here is a simple brief to help you focus on a defined area in which to choose your portrait subjects.

1. Decide on a specific area near to where you live or study. This should be defined by a series of roads that will provide your parameter.

2. Set yourself a time constraint of one week in which to complete the brief, then walk every day around your chosen area at the same time in the same direction and on the same route, photographing people on the street.

3. Try to get close to them, to speak with them after you see them a couple of times, to find out about them, what they do and why they are in the same place each day. Re-photograph them each day and start to build your confidence in approaching strangers.

4. At the end of the week edit the work and assess where you have succeeded and where you have failed, then define a different area and repeat the brief over the following weeks until you feel that you want to stop.

WHAT DOES IT TAKE TO BE A MUSIC OR SPORTS PHOTOGRAPHER?

So why have I joined these two areas of specialization together? Although the subject matter may be different, the process of shooting both and getting commissioned is pretty similar. Both are based on recording action in often difficult surroundings; both will involve you completely immersing yourself into a specific culture; both will require that you know your subject in detail; and both will require you becoming invisible to get great images.

These band portraits by photographer Courtney Brock illustrate the possibility to create creatively innovative photography in different locations, even when initially they do not appear to offer much for the photographer to work with. Music photographers have to work with the environments they find themselves in, while also creating images appropriate to the music the band is creating.

*If you make something with love and, you know,
passion and you tell a real story, I think it will always
find an audience somehow, you know.*
Photographer: Anton Corbijn

*You shoot for a very powerful portrait or you try
to shoot and catch 'em off guard, where there is a
moment that is sort of surprising and just takes you
away from the ordinary.*
Photographer: Walter Ioos

What I mean by being invisible is to fade into the background, become part of the environment to such an extent that the people you want to photograph forget that you are there taking photographs. It is at this point that the photographs that 'get under the skin' of a situation or sportsman or woman or performer are created. However, to get yourself into these situations you need what is referred to as 'access.' This access is the golden key to both sports and music photography: without it you remain an audience member, separated from your subject matter; with it you will be at the front and side of the stage, maybe even backstage or on tour, and you will be at the edge of the pitch or track, in the thick of the action, an inside observer behind the scenes of the public personas of those you are there to document. To get this access you need to get a press/photo pass for every event with, if possible, 'Unlimited Access'—that really is the golden ticket, and the bigger and more prestigious the event the fewer passes there are and the harder they are to get. However, they're not impossible to obtain, so this is how to go about it and how and where you will be expected to work:

1. A press or photo pass is given out on the basis of press accreditation (a magazine or newspaper of some kind asking you to take photographs for them) and is sanctioned by the band or team's management or an event organizer. With one you will be allowed to enter the venue as a professional photographer to take pictures of the concert or sporting event. As the magazine or newspaper is your client, they will get in contact with the organizer prior to commissioning you to see if photographers are allowed, and if so how many and what restrictions will be in place. As part of being given a pass (or wristband) the band management, team or organizer will usually require that photographers sign contracts before they begin shooting. They also check the publication's importance: the bigger its clout, the more access you will get, but the smaller it is the less access you will get, if any at all.

2. Once you have your pass you will have access to the photo pit in front of a stage or in designated shooting areas at a sporting event. You are usually only allowed to shoot from the photo pit for the first three songs before you get kicked out of the pit. For sports events, you should be able to shoot throughout the event, but don't expect seasoned veterans to give up their positions for you or to make your job easy by getting out of the way of your shot.

3. There is no way you will be able to shoot on stage, backstage or in or near dressing rooms without knowing the manager or the band. A normal pass will not get you into these hallowed places; for this you will need an AAA ('access all areas') pass.

4. The great thing about both music and sports photography is that you can get lucky and meet, befriend and photograph people at the beginning of their careers. They may well be your age when they get started, and they may be the college band or sports

captain! This can give you the access you need directly from the subject rather than via management with their own friends, favorites and agendas. Images of the early days of a music or sports career can also turn into a valuable archive.

Extreme sports photography has been eagerly adopted by many of those engaged with the sports they are so passionate about. It is an area of specialization that demands insider knowledge to capture images that are both compelling and authentic. Photographer Rob Gifford is passionate about skateboarding and documenting the sport, as his images illustrate.

5. Whatever access you manage to get you can expect to be shooting outside of normal working hours, in all types of lighting conditions and in all types of weather. If you like the idea of responding to the unexpected, then both music and sports photography are going to give you exactly what you are looking for.

There is no set commissioning template for these two genres of work for me to outline. By it's nature music photography commissioning is very much based on friendships, with work appearing online, in

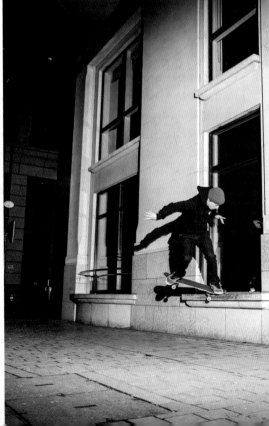

magazines and on CD covers, programs, T-shirts and posters, while sports photography has moved more towards an agency template, with photographers supplying agencies with international connections to sell their images to magazines, television, online and newspaper clients. However, the portrait photography template does apply to both music and sports photography, when a client commissions them for a specific purpose.

There is an awful lot of waiting around to try to capture that special picture. You would think that sports photographers just turn up and shoot the event, but it's not like that.
Photographer: Bob Martin

Check These Music Photographers Out

Anton Corbijn
Penney Smith
Jill Furmanovsky
Annie Leibovitz
Kevin Cummins
Mark Seliger
Charles Peterson
Janette Beckman
Baron Wolman
Elliott Landy
Gerard Mankovitz
Ken Regan
Mick Rock
Brad Elterman
Jenny Lens

GO SHOOT A BAND!

If you are into music it is quite likely that you will know someone in a band at college or locally, and that you will be seeing bands, singers and DJs at local clubs, festivals and bars. If so, it is just a small step from knowing them and seeing them to photographing them. Large music venues and festival sites offer their own problems, and you will often hear professional music photographers complaining that they no longer get to shoot in small atmospheric venues, so why not make the best of what you have on your doorstep? Here is a brief to get you started.

1. Contact a local venue and find out who is in charge and arrange to go and meet them.

2. Suggest that you'd like to come to the venue regularly over a year and photograph the bands for free, if they don't already have

someone doing this for them. (It is essential that you don't undercut or offer work for free if local professional photographers are already being paid to do the same job.) The idea behind doing this would be to have an exhibition at the end of the year, maybe in the venue itself. Offer to give the venue some free prints at the end of the exhibition as a thank you, and don't forget that there is a strong possibility that you will sell prints to those in them as well. If you have no luck, move on to another venue and try again.

3. Research photographers whose work has been created in small venues, and decide what you think works best as a starting point for your work. Start a project-specific blog and Twitter feed on which to post work as the project develops, with captions explaining the images and your experiences shooting them.

4. Find out which bands are playing over the coming weeks, decide which will give you interesting characters to work with and build yourself a shoot schedule.

5. Get to the venue in the afternoon or whenever they are booked to do a sound check. This is a great time to meet the band and their management, shoot informal portraits, and maybe hang out with them to talk about your project. A tip here is to always talk with the management of the band before you talk to the band members or take any pictures. Explain the project and show them images from previous shoots (this can be on your phone). The venue may have given you permission to shoot, but the management always has the final say along with the band, so don't expect to shoot every band that appears.

6. Each time you photograph a band make sure that you shoot them pre-performance, during performance and after if possible. File each shoot and edit the strongest images from each category as you go along. Use these edits to learn what you are getting right and wrong, responding to the negative aspects within your image creation on the next shoot.

7. At the end of the year put all of the individual edits together into one big edit and create your final exhibition edit, following the edit process I outlined in Chapter 3. Now a year may seem like a long time (although it will go really quickly), so if you would rather work on the brief for a shorter time then do, but make sure that it is for no less than one month, and only do this if it is a busy venue with acts every evening.

SHOOT SPORTS

Great sports photography doesn't have to come from great events, it can just as easily be created shooting your college team, some friends skateboarding or any locally-based sportsmen or women. The important thing is to get close and persevere. You are not going to get 'the shot' in just one shoot. Here is a brief to work on to help you start building a body of work.

1. Contact a local team. It doesn't matter what they do, just as long as you are interested in the sport they are involved in. It could be soccer, cycling, baseball, swimming, running, cheerleading, anything at all, and they can be any age from young to old.

2. Speak with whoever is in charge of the team and explain that you would like to spend a season documenting the members of the team, before, during and after whatever it is that they do, with the idea of the work becoming an exhibition at the end of the season, maybe in their clubhouse or training facility. Offer to give the team some free prints at the end of the season as a thank you, and don't forget that there is a strong possibility that you will sell prints to those who are in the photographs as well.

3. Research the photographers who cover the sport professionally and the types of images they take and when. Then look to create

Check These Sports Photographers Out

Mark Pain
Marc Aspland
Graham Watson
Bill Frakes
Max Rossi
Bob Martin
Ian MacNicol
Barbara Walton
Ed Mulholland
Jorge Jimenez
Vladimir Rys
Mark J. Rebilas
Bernard Brault
Darren Heath
Sergei Ilnitsky
Erik Refner
Neil Leifer
Walter Iooss

your own approach; do not try and replicate what they do. Make your images more personal, as you will have much better access than the professional photographers will have to international stars.

4. Divide your work into three areas: Training, Competing and Post-Competing. Take different lenses with you for each. Look to create close-up and environmental shots of the training, action shots (you will probably need a fast, long lens for this) of the competition and portraits and environmental shots for the post-training.

5. Be open to the work going in different directions. If you connect with one particular person or persons, document them. If the story is about the team, make sure you keep your story clear throughout the season: Do they always win, lose? Why do people play for that team? What is their history? and so on.

6. Keep all three bodies of work separate until the end of the season, and only then bring them together to create a final exhibition edit.

WHAT DOES IT TAKE TO BE A FOOD OR STILL LIFE PHOTOGRAPHER?

Again, I have grouped two areas of specialization together, as they share a number of similar elements in approach, practice and commissioning. Food photography requires a love of still life photography (and food, of course!), and still life photography requires a love of perfection, composition, textures, colors and light, all of which are intrinsically important to food photography. If you are a person who lives by the belief that God is in the details, then either or both of these areas of specialization could be for you.

I have spent a lot of time working with still life photographers, and I know that I don't have the required patience to devote my time to this kind of work, so if you have a short attention span and little

If you have a great friend who is a great cook, or if you have the level of skills to create food good enough to photograph, you have an obvious advantage when it comes to exploring food photography. Photographer Emma Boyns bakes and cooks all of the food she photographs, and she styles her images to the professional standard required of this area of specialization.

patience, then these are not fields for you to explore. However, if you enjoy coming up with creative concepts, mastering lighting problems, working with medium- and large-format cameras, being in the studio and bringing innovative approaches to photographing everyday objects, then still life photography could be for you. If you add a passion for food to these personality traits, then food photography may be the right area for you to focus on.

Still life photography embraces both conceptual, highly technical studio-based work and the documentation of found/seen objects in their environment. The simple graphic composition created by photographer Kasia Fiszer illustrates the importance of balance in color, composition and prop styling required in the best still life photography, which are also the skills that she has brought to her observational triptych documenting an artist's studio. The image of multi-colored macaroons was created by photographer Catherine Walter and illustrates the importance of understanding the correct point of focus within a successful still life image.

Although I have grouped these two areas together, there are a few specific differences between them. True still life photographers are a special breed who are highly technically gifted and trained, prepared to devote hours photographing just one object or group of objects and masters of reducing and controlling reflections and highlights. This is especially true when it comes to those specializing in jewelry and beauty products. Over recent years the additional skill of high-end post-production ability has been added to these requirements. You can get someone else to do this for you, but wouldn't it be better and quicker if you could do it yourself and charge the client for doing it! The still life photographer is the ultimate visual problem-solver and needs a brain and an eye that solve the seemingly impossible client demand to help sell the client's products.

You should want to eat the food from the page. It has to look tasty and fresh.
Photographer: David Loftus

This selection of images created by photographer Catherine Walter illustrates her ability not only as a photographer but also as a stylist. She has collected all of the items she has used in these images from charity shops, flea markets, online auctions and department stores.

Depending upon the area of food photography you want to enter, food photography can offer more opportunities to work in a looser way. You can, if you wish, adopt a studio-based approached similar to the traditional still life photographer, or you may wish to work only with natural light and photograph on location; you may wish to shoot producers and growers, or you may wish to shoot the making and creating of products and dishes; or as is most likely with food, you may want to try and perhaps continue doing a mix of all of these things. With food photography you can explore still life, documentary and portrait approaches to your image making. Each of these practices has a different way of being commissioned, but here is an outline of how you can expect to work as a studio or location-based still life or food photographer who photographs products or completed food dishes.

1. Just as in any area of professional photography, you will be commissioned to shoot a series of images based around one story, such as spring salads, hearty soups or small luxury leather handbags or red lipsticks.

2. You will probably be commissioned with a strict creative brief, with the client outlining to you their ideas and concepts. There may be space for input from you or there may not; either way, the client will usually expect you to help source props and provide the answers to how their concepts can be fulfilled.

3. You can expect to work as a team on the shoot day and in pre-production (getting ready for the shoot). In the case of food shoots, you will be working with a home economist (who will check the recipes and cook the food on the day), a stylist (who will source the props) and the art director (who will work with you to create the final images). It will be the same team for a still life shoot, however the home economist will be replaced by a beauty editor, an accessories editor or a fashion editor, depending upon the items being shot. Of course you can add at least one client to the mix, plus advertising agency representatives if it is an advertising-based shoot.

4. Whether you are working in the studio or on location, the requirement of this kind of work is that you will be using either medium- or large-format cameras tethered to a laptop or a computer with a screen so that each image can be viewed and discussed. Everyone on the shoot will have an opinion, and you will have to be able to deal with them all and control the discussion politely but firmly.

5. Because of this on-shoot debate, you will be making decisions with the team and client during the shoot as to which is the most successful image, so the edit process will be much simpler. However, you will also be discussing possible post-production changes to the image, so it is a good idea to note these down throughout the day, go through them with the client at the end of the day and follow this up with an email detailing these changes before you spend time and money implementing them.

6. A successful shoot will produce images that everyone is pleased with and a happy team. That second part is a vital part of the photographer's role to facilitate: these kinds of shoot can be very pressurized, and you will need to find a balance in creating the images between intense concentration and balanced humor.

One of the great aspects of experimenting with this kind of photographic specialization is that your subject matter is easy to access and shoot, if you source objects that give you creative possibilities. A banana is not easy to shoot, but an onion straight out of the ground offers all kinds of possibilities. So as in all areas of photography, don't start off by being too ambitious: keep it simple, experiment with your lighting and get your technical skills honed by photographing objects you own or simple food products from a local grower or food market, avoiding overly perfect produce from some supermarkets. If you like the idea of working in either of these areas, here are two briefs to get you started.

START SHOOTING FOOD

Food photography has gone through a revolution over the last few years, thanks to the proliferation of food bloggers, people passionate about food who write about it and photograph it for their own pleasure without a commission or payment. These bloggers have helped bring about a move away from overly styled food photography and towards more 'believable' images. However, it is important that you understand the fundamentals of lighting and composition if you want a career in professional food photography. Here is a simple brief to help you start out on the right road.

1. Create a simple tabletop studio space consisting of two white boards standing on the longest side joined at one corner to form an 'L' shape. Place this near to a window that preferably faces north; the window will now form the third wall of your studio space, and you have now created a daylight studio.

2. Choose a food product such as an apple, a pear, a piece of cheese, a loaf of bread—something that has interesting textures, shapes and colors within it. Place the item within your studio space and take a series of images of it throughout the day as the light conditions change. Shoot against the white of the studio you have created, and introduce a piece of black velvet to see how that changes your images. You could introduce a piece of wood, slate or stone as a base and reshoot the item. Use the studio you have built as a lighting and textural testing center.

3. As part of this process, you could start to introduce props that you have sourced to develop your compositional skills.

Check These Food
Photographers Out

Simon Wheeler
Tessa Bunney
Jean Cazals
Tim Clinch
Jonathan Gregson
Laura Hynd
Jason Lowe
David Loftus
Tessa Traeger
Marcus Nilsson
David Munns
Clare Barboza
Carl Warner
Carol Sachs
Sarka Babicka
Toby Glanville
Jonathon Lovekin

As I have mentioned, a professional food photographer can expect to work with both a home economist and a stylist, but when you are starting out this is not going to happen, so you are going to have to do the cooking and the propping! Propping is not so difficult, as it just involves you building a store cupboard of chopping boards, interesting textural surfaces, china, cutlery, saucepans, cups, bowls and dishes as cheaply as you can. The cooking can be more of a problem: when you start out you will need to create dishes to a photographic standard (in all of the food images in this book, the food was cooked and propped by the student photographers who took them). This level of food preparation is not impossible to achieve, but it is a challenge you need to be aware of when you are ready to move on from simple produce-based briefs to photographing finished dishes.

SHOOT A SERIES OF FOUND OBJECTS

This is a great, fun brief to find objects to shoot and to experiment with lighting set-ups and created environments for still life shoots. I don't believe in spending lots of money on props, so just as with the fashion brief, this one will require you to scour charity shops, boot sales and flea markets.

1. Set yourself a budget and purchase six items that interest you that are connected by a theme. For example, you could buy a series of drinking glasses, vintage bottles, decorative plates, anything that is going to give you visual problems to create one image.

2. Once you have your items, think about what you are going to use as a surface to place them on and the background you are going to use. Think about reflective surfaces, textures, patterns and colors. Decide on the atmosphere you want for your image and the lighting you are going to use.

3. Create a composition of your objects slowly, by placing one item at a time into the environment you have created. As you add an item take a frame and check your lighting, looking out for highlights and shadow areas. Move your lighting appropriately and use small pieces of card to bounce light and pieces of card covered in metallic foil to reflect light. Slowly build your composition until you feel that you have created a successful image.

4. If you've enjoyed the process, go out and buy more items based on a different theme.

Check These Still Life Photographers Out

Paul Bowden
Graeme Montgomery
Mark Mattock
Guido Mocafico
Ori Gersht
Stephen Lewis
Carlton Davis
Lacey
Sebastian Mader
Sam Kaplan
Jenny Van Sommers
Michael Baumgarten
Jonathan Kantor
Irving Penn
Edward Weston
Jonathan Knowles

WHAT DOES IT TAKE TO BE A LIFESTYLE, INTERIORS, ARCHITECTURAL OR TRAVEL PHOTOGRAPHER?

This time I've brought together four areas of specialization, as all three have very similar elements in their photographic creation and in the process of commissioning. In fact, in many ways they all require elements of each other, even when they are seen as areas of specialization. They all also require an ability to shoot portraits.

Interiors photography requires that the photographer understands how to create a narrative that explains how a house works and how the people who own the house live in it through their possessions and decoration choices. Here photographer Kasia Fiszer illustrates how to partner images and isolate areas of interest.

119

Sometimes my images are more about the subject, with the interior as an adjunct; other times the person doesn't appear at all. I try to explore what people have in their lives.

Photographer: James Merrell

Let's start with interiors photography. The genre of interiors photography is rarely spoken or written about while interiors photographers quietly go about their business creating images that shape and inform the homes in which we live. Often dismissed as 'lifestyle'—a weak, lazy and general term that completely misunderstands the art of interiors photography (but please don't get me started on the misuse of the term 'lifestyle;' I will explain this later in this section).

Since the earliest photographic experiments of William Fox Talbot, photographic practice has been obsessed with recording spaces: the interiors and exteriors of the buildings in which we live. Its foundation has been in capturing light and portraying the truth, through controlled composition and the detail of everyday life. These aims are also the foundations of interiors photography; there is no room for Photoshop trickery, sloppy composition or badly lit images in the world of the interiors photographer. If you enjoy design, architecture, the way people live and creating photographic images based on composition, textures and color, then interiors photography could be for you.

Interiors photography does not require a large amount of technical lighting ability (unless you are shooting constructed room sets for advertising campaigns), but it does require the photographer to understand how a room works, how the spaces interlock and how the elements within it can come together to form a narrative of how somebody lives in the house. Portraiture is often required as part of an interiors commission, and this will usually take place within the house and be as much a part of the interiors story as the images of the unpopulated rooms.

To create successful architectural images it is essential for the photographer to understand the architect's intentions in creating the building, how it interacts with its environment and how it is used. Photographer Liam Clarke illustrates all of these aspects in this series of images from a selection of narratives documenting buildings in the United Kingdom and Germany.

This should not be confused with architectural photography, which is a highly skilled area of specialization in its own right. Often commissioned by architects to create a record of their work, architectural photography requires great technical experience to capture the structural essence of buildings and architectural environments, as well as a refined aesthetic ability to understand the architect's vision. Just as with all other areas of photography you need to have a passion for your subject, and architectural photography is no different. So if you love architecture and the ways in which buildings are built, you should look towards architectural photography rather than interiors photography as a career path.

Of course, as an interiors or architectural photographer you will be commissioned to photograph houses wherever they are nationally and internationally, and therefore travel becomes an intrinsic part of your role. You would therefore be expected not only to shoot the house but also to put it into the context of its environment.

Travel photographers are of course focusing on that environment to find their narratives, and you only have to look at magazines such as *National Geographic* and *Condé Nast Traveler* to see the breadth of stories there are to be told as a documentary travel photographer, from environmental issues to population crises, from natural disasters to exploration of wildlife behavior. Unfortunately, the clients for this work are few and far between, and the travel photographers not being commissioned for titles such as these or by NGOs (Non Governmental Organizations such as charities) spend most of their time pitching stories and ideas to clients or self-funding shoots to supply stock agencies with images. In a world in which most of us have an opportunity to travel, the travel photographer's challenge is finding new and important stories. Don't let me put you off the idea of travel photography, but be aware of the importance of a story. Be especially aware that it will not be good enough to just create beautiful-looking landscapes in this marketplace.

The onus is on you: you have to have a strong style and vision and an eye for great stories that the media will want. It's never been easy, it's never been harder, but at the same time there have never been more opportunities.

Photographer: Ed Kashi

This move away from commissioned shoots has also affected the interiors market that was once entirely based on commissioning. Today magazines are looking for stories and are open to photographers with images of houses they have gained access to and will be able to shoot for the magazine if the magazine wants to pay them to do so. This form of pitching rarely works in other photographic specializations but it is the dominant factor within interiors photography. The magazine will expect to see what they term as 'recce' shots (snaps of the interior and exterior of the house) and some background information about the owners. If they like what they see and hear and feel that you will be able to do a reasonable job photographically, the chances are that you will get commissioned. The secret to success, however, is in understanding the type of houses the magazine features and wants and what makes an interesting interior.

These self-motivated shoots can also provide a reasonable income when given to stock and syndication agencies to sell for you. I'll go into more detail about how these work in Chapter 7, but it is an easy process to understand and engage in for a lot of photographers looking to earn a living when commissions are scarce.

The answer is in the question: lifestyle photography is about lifestyles, and therefore it can include a wide range of areas of photography, including portraiture, interiors, food, still life, children, pets, anything and everything that makes up the lives we all lead. The interesting thing about lifestyle photography is the interpretation of the lifestyle being photographed. The tendency for this kind

of work is for it to be a client's idea of family perfection, which can in turn lead to work that is lovely to look at but generic in it's aesthetic. In short, lifestyle photography can often look like a series of set-up, weak clichés in a soft-focus positive world. That's why I personally have a problem with the term 'lifestyle.' If you want to shoot this kind of work then do, but please, please, please avoid the clichés.

Check These Interiors Photographers Out
James Merrell
Simon Upton
Horst P. Horst
Francois Hallard
Ingrid Rasmussen
Jan Baldwin
Todd Selby (aka 'The Selby')
Tim Street-Porter

START SHOOTING INTERIORS

There is a common belief that interiors photography is all about beautiful homes, but it doesn't have to be. The art of documenting living spaces is the same whatever the decorative qualities of the rooms you are photographing. Here is a brief to get you started that could not be easier to complete.

1. Ask all of your friends if you can photograph their bedrooms.

2. Create a narrative story about each room, making sure that you photograph the room from different angles, still lifes of objects and collections in the room and a portrait of the person who lives in the room sitting on his or her bed.

3. Edit each shoot after you have done it, and do as many as you can.

SHOOT BUILDINGS

Have you ever really looked at the building you attend every day as a student? I mean really looked at it? What it is built from, how the light falls on the walls, how it has been extended and developed with new additions over the

**Check These Architectural
Photographers Out**
Jim Stephenson
Dennis Gilbert
Daniel Hewitt
Simon Kennedy
Roland Halbe
Nicolas Grospierre
Fernando Guerra
Iwan Baan
Helene Binet
Julius Shulman

years? Here is a project that will make sure that you do, and that will help you understand why buildings are designed for a purpose.

1. First of all, get permission to photograph your building, and ask if you can have access to the building in the morning before the students have arrived. Suggest that you could exhibit the work in the institution when it is completed.

2. Start by photographing the building, including its environment. Then move on to photographing textures, where walls meet and the structures that support the building.

4. Move around the building, investigating and documenting the building and focusing on the elements that give it its architectural personality.

4. When you feel that you have successfully documented the building, edit your work and produce a series of images that tell a narrative about the building that could be exhibited.

FIND A TRAVEL STORY TO TELL

**Check These Documentary
Travel Photographers Out**
Ed Kashi
Timothy Allen
Art Wolfe
Jack Hollingsworth
Bob Krist
Sam Abell
Thomas Abercrombie
Sebastiao Salgado

Most of us go on holiday and return with a series of images documenting where we have been, who with and what we got up to! But how many of us look more deeply into the lives of the people living in the area we visit? Here is a brief to encourage you to do exactly that and to create a documentary travel story.

1. Next time you are on holiday with your family or friends, find some time to explore the area and people who live in the area you are visiting.

2. Talk to them and find out how they live, what they do and why. Through your conversations try and find a story or stories to photograph. This could be as simple as documenting how a local family lives or the life of a fisherman or farmer. These are pretty obvious ideas, and I am sure you will be able to do better.

3. Once you have decided on your story, begin to create a series of images that tell the story you have focused on, spending a little time each day of your holiday on the project.

4. Edit your work as you go along, adding to the story by deciding what you need and what you have already successfully covered.

5. At the end of your holiday you will have a unique reminder of your stay, and you will have had an insight into where you have been that the rest of your travelers will not have had. You may also have made some new lifelong friends and a reason to return to the place you visited.

YOU HAVE NOT MENTIONED WHAT I WANT TO DO!

The areas of photographic specialization I have focused on are the main areas of commissioned photography that cover both editorial and advertising environments. But of course there are many other areas and subgenres within the areas I have discussed. If they are subgenres, say extreme sports photography, for example, then they roughly follow the rules I have outlined for sports photography, and the same is true of street wear fashion as a subgenre of fashion photography. However, if you are looking for landscape, pets or wildlife, I have not included them, as they are not areas of specialization that can rely on commissions on a consistent basis.

They all rely on each photographer's approach to create a business around his or her photographic passions specific to their financial needs. Some will use part-time teaching and workshops to support their work, others book publishing, others grants and bursaries, and many landscape photographers produce their own calendars and greetings cards! Whatever lets them shoot and is legal, they do!

CONTEMPORARY ART PHOTOGRAPHY

There is a similar situation for photographers who do not want to enter the world of professional commissioning and instead want to create work free of commercial interference. Everyone who wants to make a living out of being a photographer needs someone to pay them for their photography in some way. It doesn't have to be as a commission; it could be through buying a print, a book, a poster or as I have just said through grants and bursaries that can be applied for. If you earn all or part of your living through photography, it is your profession, and you are therefore a professional photographer. It's important to understand this, as there is just as much work in promoting and marketing your own self-initiated work exhibition or book as there is trying to engage with commissioning clients.

In the past there was (and in some places there still is!) a belief that self-initiated art photography was intellectually and aesthetically superior to commissioned photography, despite the fact that some of the most iconic art photographers of the last century also accepted commissions by magazines. Today it is an even more ridiculous position to take, as photographers such as Nadav Kander, William Eggleston, Nan Goldin, Larry Clark and Ryan McGinley move seamlessly between the editorial, advertising and art worlds.

If you feel that you want to work purely on self-initiated work you need to understand how you will support yourself and your work. You can follow a lot of the photographers working in this way on Twitter, meet them at talks and watch and read interviews with them online to engage with those whose work interests you and find out how they have created their own photographic practice.

TO ASSIST OR NOT TO ASSIST?

For many years the tried and trusted route into the world of professional photography was through assisting. Nearly every photographer had at least one assistant to load film into cameras, move lights, carry bags, make tea and coffee and generally be helpful. Assistants were never paid that well, but many worked full-time for photographers, and the experience they gained from being on shoots and meeting clients was invaluable.

However, reduced budgets and the arrival of digital capture have meant that the number of assistants being used has dropped dramatically, while the pay has not increased. However, the role has! Assistants are still expected to make tea and coffee, move lights, carry heavy objects and only speak when spoken to, but they also now have to fulfill the role of digital assistants. The digital equivalent of loading and unloading a camera with film is downloading, changing cards and opening those downloaded files within a software package such as Photoshop, Lightroom or Capture One. It is therefore obvious that if you are looking to assist you are going to need to know how to do these tasks as well as fulfill the more traditional roles of an assistant.

The level of your digital ability will also decide your progression as an assistant. Many assistants take on minor post-production work for the photographers they are working for, while others progress to being high-end digital operatives on shoots commending

The Ten Most Expensive Photographs Ever Sold
If you have any doubt as to the worth of photographs within the auction and art worlds check out the prices these prints have reached.

10. *Billy the Kid* (1880): Photographer: unknown, $2.3 million
9. *Untitled #153* (1985): Photographer: Cindy Sherman, $2.7 million
8. *The Pond Moonlight* (1904): Photographer: Edward Steichen, $2.9 million
7. *Los Angeles* (1998): Photographer: Andreas Gursky, $2.9 million
6. *99 Cent II, Diptychon* (1999): Photographer: Andreas Gursky, $3.3 million
5. *Untitled (Cowboy)* (1989): Photographer: Richard Prince, $3.4 million
4. *Dead Troops Talk* (1992): Photographer: Jeff Wall, $3.7 million
3. *For Her Majesty* (1973): Photographer: Gilbert & George, $3.7 million
2: *Untitled #96* (1981): Photographer: Cindy Sherman, $3.9 million
1. *Rhein II* (1999): Photographer: Andreas Gursky, $4.3 million

high fees. The other new roles that have come about over the last few years are as a social media assistant and behind-the-scenes filmmaker.

The role of social media assistant will involve you posting images onto the photographer's Twitter feed of the shoot as it progresses and shooting the same type of in-progress shots for their Instagram account. I know of one client recently who not only wanted the photographer to have an assistant who could do this but was also willing to pay extra for the assistant to post the images on the client's account as well!

As I have discussed, the ability to create moving images has become an essential skill in the twenty-first century photographer's toolkit, and it is increasingly the case that assistants are being asked to create the behind-the-scenes on-set footage that the photographers are being asked to supply. A good assistant who can also shoot film and edit it is fast becoming a valuable person to be able to call on for any professional photographer.

It doesn't matter if you're photographing a porter in a market in Marrakech or you're photographing the King of Morroco. You have the same sympathetic approach. You have to be nice to everybody, basically.
Photographer: Albert Watson

The role of the photographic assistant still exists and can still be a great learning experience, but there are fewer positions available and it has therefore become highly competitive. This has made average assistants dispensable and poor ones unemployable. Working as an assistant is physically tough and not for the uncommitted. You can expect to work very long, unsocial hours and be so tired at the end of the week that the last thing you will want to do

is take your own photographs. But despite all of this it is an option for some of you.

If you are wondering how you get work as an assistant there are two ways. The first is to approach a photographer whose work you admire directly. Don't phone up or send an email asking to be an assistant, however, unless you have some previous experience; instead, ask for some feedback on your work and a possible meeting for advice. If this goes well, ask if you might be able to come on a shoot; if this goes well, ask about the possibility of second assisting for free. Slowly but surely, if you do well at each stage you will be considered as a possible future assistant.

The other alternative is to apply for an assisting position at a large hire studio complex. Most big cities have a few of these, and they all employ a few contracted members of staff and maintain a list of freelance assistants to recommend to photographers booking the studios. The days when all photographers have their own studios are long gone; now photographers rent the studio space they need for any particular job, and the studio complexes provide a full service of equipment and assistant hire, which can be invoiced directly to the client. These complexes are great places to work if you want to gain experience from working with a whole host of different local and international photographers, but you will need to be available seven days a week, twenty-four hours a day.

THE GOOD, THE BAD AND THE CAPPUCCINO

So who is going to commission you? Sometimes somebody experienced in commissioning photography, such as an art director or art buyer, or someone whose job it is, such as a picture or photo editor, but it is more likely that it will be someone who has very little experience or knowledge of photography. You would think that the first two would be the best people to be commissioned by, but it is

not that simple. Unfortunately, there are bad commissioners in all areas of photographic commissioning, no matter what title or post the person has. I break down the world of commissioning into three distinct types; the good, the bad and the cappuccino.

The Good

The good love and understand photography, and they commission photographers whose work they like and think is appropriate for the commission. They therefore give photographers the space to do what they do and to interpret the brief. They may come on a shoot, but if they do they will be there to support and advise you only when needed. When the work is submitted, they will champion your work and stand up for the images you have created. They see their job as a vocation and part of who they are.

The Bad

The bad will do none of those things. They will have very little understanding or love for photography, and they will see their job as a job and nothing more than a job. They will give you a brief and expect something different. If they come on the shoot, they will interfere and be inappropriate in their suggestions. You will deliver your images, and they will not support what you have done and blame you for not listening if anyone else criticizes the images.

The Cappuccino

The cappuccino will be easy-going from the start, give you the impression that you have total freedom, say to you they don't give briefs, arrive at the shoot, have a cappuccino and leave, saying that they have to get back to their office. When you submit the work they are shocked that you have not done what they thought you were going to do, even though they never told you what they wanted. They will not stand up for you and only look out for themselves.

You will repeatedly come across the second two and only occasionally meet the first. How you deal with them and if you choose to work with the bad or the cappuccino more than once will be up to you, but you will learn the most about the business from commissions that go bad and the most about photography from working with good people.

Visual ideas combined with technology combined with personal interpretation equals photography. Each must hold it's own; if it doesn't, the thing collapses.
Photographer: Arnold Newman

THE IMPORTANCE OF THE MOVING IMAGE

THE CHANCES ARE THAT whatever device you currently use to take still photographs will also allow you to create moving image films, but I wonder how many of you press the button to make films, how often you do and why you do if you do! You can answer those questions yourself, but the one big question I need to answer for you is why we are even talking about the moving image or filmmaking in a book for photographers!

> *Still images can be moving and moving images can be still. Both meet within soundscapes.*
> Photographer: Chien-Chi Chang

Lets start at the beginning and decide what we are as photographers. Everything I have spoken about so far should be leading you to two conclusions and two answers as to what the role of the professional photographer is in the twenty-first century. Those answers are a visual problem-solver and a visual storyteller. So if we accept this to be true, why does today's photographer have to limit himself or herself to the still image when engaging in these activities? When the camera we use offers another creative possibility, should we ignore that possibility? Is it because we think that photographers should only and can only take still photographs? The answer is of course, no!

For professional photographers who have been working only with the still image for years, the step towards experimenting with the moving image has been a big one, but for you it should seem like a natural extension of what you do, as the moving image is integrated in everything you look at and use.

*It was a natural transition for me to move
from the still to moving image when I got the
Canon 5D MkII—it only took the press of a button
to shoot HD video. I found that, when I showed
people my still images, it was hard to convey what
it's really like in wars, whereas the moving image
is much closer to home, you really feel what
it's like to be there.*

Photographer and filmmaker: Danfung Dennis

The catalyst for photographers to begin shooting moving image and
for filmmakers to start working with DSLR cameras was the launch
of the Canon EOS 5D MkII at the end of 2008. It was a camera
that not only offered professional-quality photographic images but
also high-quality HD film footage. Since that launch most of the
major photographic camera manufacturers, including Sony, Lumix,
Panasonic, Canon and Nikon, have been competing to improve,
refine and progress their DSLR cameras' moving image functionality
as a response to photographers' and filmmakers' excitement about
what these cameras can give them.

So photographers and filmmakers were excited about the moving
image, and the camera manufacturers were happy to make cameras
with reasons to upgrade and buy built into them, but what was and
is the commercial reason for the growth of the amount of films being
made by photographers?

The growth of online platforms such as YouTube and Vimeo has gone
hand-in-hand with this moving image revolution, as has the growth
in people watching on-demand films and television programs online.
The development of website technology to host and stream large
moving image files and to deliver them to your computers and mobile
devices via fast broadband has seen those platforms and compa-
nies eager for moving image content to post. So as more content
is needed but no more money to pay for that content, the answer

is low-budget filmmaking created by small teams and independent filmmakers using DSLR cameras.

THE YOUTUBER COMMUNITY

It's at this point that I'd like to talk about something that you are probably very aware of but maybe not as part of engaging with the professional world. How many of you watch YouTube films made and presented by YouTubers? Beauty tips, gaming films, comedy shorts all created by people across the globe in their late teens and early twenties, made for no payment and made available to you for free. Or are they? You may have heard stories of YouTubers becoming online celebrities with huge followings and even larger incomes, but do you know if this is true? Well this form of moving image creation is very much part of the future of television, thanks to the support of YouTube and its owner Google.

The YouTubers are making money on the basis of the amount of views their films are receiving and the advertisements that they start with. This obvious commercial element to homemade films is often enhanced by in-film product placement and live appearances at YouTube events. The professional world has been slow to pick up on the power of the YouTuber, but slowly they are starting to get involved, offer roles within traditional media to the presenters and employ the ideas used in these films within traditional advertising campaigns. As with all underground movements YouTube is starting to become more mainstream, but there is no doubt that it has developed an engaged audience based on word of mouth and online recommendations, a community of specialized audiences that you should consider as part of your filmmaking development.

EXTREME SPORTS LEAD THE WAY

Just as the YouTuber community embraced YouTube and lo-fi film-making, those engaged with extreme sports and street sports engaged with one of the most revolutionary cameras of the past ten years, the GoPro. This small, super tough, reasonably priced camera allowed all of those incredible skateboarding, snowboarding, skydiving, climbing, bungee jumping, BMX riding, surfing and diving films to be made from a POV (point of view) perspective. The GoPro enabled people not only to capture the incredible feats they were achieving but also to do so from the point of view of the person doing it. Suddenly you were seeing what the person doing the activity could see. These high-octane films were just what YouTube and social media were made for: easy to upload and share, the extreme sports GoPro film quickly flooded the online environment.

Just as with the YouTubers, traditional media was slow to see the commercial potential of these films and started to use the amateur films as inspiration for traditional Hollywood filmmaking and television advertising. We are now at a stage where we have reached the saturation point for this kind of film, and as an audience we have come to accept what only a few years ago was impossible or incredible. The GoPro introduced a way of filmmaking into filmmakers' visual vocabulary that is definitely here to stay.

GETTING COMMISSIONED TO SHOOT MOVING IMAGE

Companies now want moving image short films for their websites and their moving image billboards, and they are looking to photographers to create stills and moving image on the same shoots for the same budget. This is the commercial reality of the moving image, and it is rapidly becoming an essential skill in your photography

kitbag. Professional photographers are losing work if they can't do both, so it makes sense to at least experiment with it, to see if it works for you.

The university photography course I lecture on has the moving image embedded as compulsory modules in all three years of the course, because we think it is that important. Initially, many of the students are nervous about the technical and creative challenge that moving image presents, but as with all areas of lens-based media, if taken slowly it can be understood and enjoyed.

You may be on a course that refers to the moving image as 'multi-media,' or you may have heard of this term and not understood what it means in relation to photography. Simply put, it is a term that comes from the early days of online news when photographers were experimenting with still images with an audio soundtrack in a slide show format. Of course, once the moving image came into this equation, the combination of stills, audio and the moving image became filmmaking, and the term 'mixed media' became both redundant and inaccurate. You might like to have this discussion with your lecturers or teachers, depending on how open-minded they are to the changes the world of photography is going through. I leave that call up to you!

Whatever you choose to call it, the moving image cannot be ignored by professional photographers, but it is not only the case that the moving image remains separate from the still image. I know of a very successful food photographer who also shoots and directs television commercials for a major supermarket chain. Because of the quality of the moving image files, it is now possible for the client to take a still from the television commercial to use as a newspaper advertisement. This presents all sorts of payment and copyright issues for the photographer to resolve, but the fact that this is happening just shows how the moving and still image are now intrinsically linked.

Editing is going to become one of the most important, sought after skill sets in the next five to ten years. I think we're going to see such an incredible amount of data coming in, to the likes of which we've never seen before, that editors are going to become one of the most important job positions out there.

Photographer and filmmaker: Vincent Laforet

All of these screen grabs were taken from films created as a response to the brief I have set you here to create a film titled *This Is My Life*. The filmmakers were all studying in a photography course and many of them had never attempted to make a film before. Pat Feeney documented a skydiver using archive and self-initiated material. Flynn Hunter did the same, documenting her mother who is an Olympic Gold Medal cyclist. Ryan Fife documented a harrowing experience in the life of his flatmate, and Abi Whiddett created a film focusing on the health issues of a fellow student.

CREATE YOUR FIRST SHORT FILM

Basic Kit to Start Filmmaking

I am not a great believer in investing in lots of expensive kit items, but after your first experiments with filmmaking you are going to quickly realize that you will need a specialist kit to progress the quality of your work. Here is a list of kit items that you should consider in addition to your camera.

1. Headphones: Good quality dynamic headphones with a closed-back design and around-ear cushions that are comfortable and provide good noise isolation.
2. Lavaliere microphone: An affordable condenser lavaliere microphone with an omni-directional pickup pattern. Consider getting two and using them with a splitter cable to mic two people at a time.
3. Rycote lavaliere windjammer: Add this to your kit if you're planning to shoot outdoors on a windy day. I am not naming brands in these recommendations, but Rycote is the leader in this field and the type to get.
4. A compact shotgun microphone: These microphones are more directional than the microphone built into the camera, and will therefore give you superior dialog recording. You will need a Rycote windjammer for this microphone as well.
5. A pistol grip: These grips are designed for accessory shoe-mounted microphones so that you can either hold the mic in your hand or attach it to a boom pole.
6. A mini boom pole: You can get away without a boom, but eventually you will find yourself wanting to place the shotgun close to the speaker but just out of frame, and this, along with the pistol grip and mic extension cable, will make that possible.
7. A battery pack: You will want at least one extra battery to extend your shooting time.
8. A movie tripod: While much can be accomplished handheld, there are many shots for which a

One of the mistakes first-time filmmakers make is to be too ambitious from the beginning, which results in them becoming quickly disenchanted. My advice is to keep it simple and respond to this brief while following the process closely. If you do, I guarantee that you will end up with a short film you will be proud of.

1. The name of your film will be *This Is My Life*, and it can be based on anybody's life but not your own. Think of people you know: family members, local businesses, bands, sportsmen, anyone in fact that you think has an interesting story to tell about their life. If their story is also visually interesting then all the better!

2. Open yourself a free Vimeo account and use this as a platform to upload your weekly shoot footage.

3. Meet your subject and spend time talking with them without filming them. Think of locations to film them in that are appropriate to their story and think about how you want them to tell their story. Take still images of them and of possible locations.

4. Create a shoot schedule on the basis of shooting once a week over a minimum of a four-week period. By working this way you will give yourself time to shoot and review your work and assess what you need to improve on and what you need to film to ensure the story is well told. Each week you will be uploading footage to your Vimeo account to view unedited. The big mistake many first-time filmmakers make is to rush into making a film, editing it and in doing so forgetting the story, the narrative that will be the foundation of the film.

5. Test! Before you begin filming your subject it is essential that you test both your filming and sound recording skills. Audio is the big challenge for many photographers, but if you follow my simple tips you should be able to achieve an acceptable result

after a few attempts. When filming you will need to be on a tripod, and this will need to have a fluid head, so as with audio follow my simple tips to help get yourself started.

6. Do your research! Look on Vimeo for other films created by one-person teams on DSLR cameras. Look at how they set up interviews and how they handle voiceovers, panning shots and the introduction of still images, if and when appropriate.

7. Finally, having tested and researched, you are ready to start filming. Inevitably, you will not create enough material on the shoot, but that's okay—this is a learning experience, and as soon as you see what you have shot you should be able to see where you went wrong and what you need to do on the following week's shoot.

8. As you upload each week's footage to Vimeo, the project should be starting to take shape.

9. After four weeks of shooting you should be ready to start an initial edit. This is where you start bringing everything you have shot into a cohesive narrative. The benefit of waiting until after you have shot for four weeks before beginning the edit is that you are now in a position to really understand the story you want to tell and how you can tell it. You may want to use your last piece of filming to start the film, or place it into the center of the film, or not use it at all. Editing is an art form, and it is possible to edit the same material into many different types of films, but it is only possible to do this once you have all of the material.

10. When you are editing don't forget the title of the film, *This Is My Life*, and make sure that your film delivers what its title suggests. Does your subject speak about their life? Is it interesting to other people? Will the viewer learn something about the person by watching the film? All of these aspects are important as you bring the film together with the aim of creating a finished

stable camera is essential, and moving image requires a heavier weight, more stable and better made tripod than your photo tripod as you progress. A solid tripod is an essential component of any kit, so look for one that feels stable with smooth head movement and that fits within your budget.

9. A sound recorder: You will often find yourself needing to record audio separately from video. A small, inexpensive recorder is a handy thing to have to collect stereo ambient sound, record audio-only interviews and voiceover narration.

10. Editing software: You will need either Adobe Premiere Pro or Final Cut Pro X and some external hard drives for media storage and backup.

11. Lighting: There are many good, small LED lights available, but the most versatile are those that allow you to dial in separately how much daylight-balanced and tungsten-balanced light you need to blend into a wide range of situations. Less expensive lights will usually be daylight balanced, but you can use colored gels and filters to change the color temperature as appropriate. However, I would suggest that you get a daylight-balanced unit and use a gel/filter over the light when you need to mix it with warmer tungsten-balanced light sources.

12. Additional camera support options: At some point you'll most likely want to add some form of camera support to your kit in addition to your tripod. There is a wide range of options available, and the right choice depends on the type of films you want to create. A monopod makes it easy to stabilize the camera for smoother handheld shots by lowering the center of gravity of the camera and allowing you to hold the camera with a grip under it. For the ultimate in floating tracking shots you'll need something more elaborate, like a Glidecam or a Steadicam. Both are based on the original Steadicam device that revolutionized Hollywood filmmaking in the late 1970s.

film of a maximum length of approximately four to five minutes.

11. Your finished film should have a consistent visual quality and soundscape (this could include recorded sounds, non-copyrighted music and recorded interviews).

12. Once you have a finished film you can add an opening title and credits at the end of the film. Again, keep your use of type simple and appropriate to the film you have made.

13. Upload your finished film to Vimeo and take down your work-in-progress posts.

Too many filmmakers, especially
photographers going into motion, move
the camera without really knowing why, or
what impact the movement potentially has.
You need to ask yourself why you are doing
certain things and what you want the results
from those things to be in your final film.
Think about whether you are trying to reveal
or conceal information.
Photographer and filmmaker: Vincent Laforet

CHOOSING A SUBJECT FOR YOUR FILM

Choosing subjects to make films about involves the same thought processes that you would use when it comes to working on a photographic project. You need to find subjects that interest you and that you are passionate about, but this form of filmmaking tends to fall into five general categories informed by the type of subject matter they cover:

1. Documentary: The telling of a factual story through a series of interviews, existing material and/or observational filmmaking.

2. Fashion Film: A series of interpretative/conceptual images, often featuring one model, created to give a sense of attitude, atmosphere and directional fashion design. These are usually set to a piece of music that sets the pace of the film and the edit.

3. Music Film: This can either follow a similar creative process as a fashion film or be based around a live performance.

4. Sports Film: It was the recording of extreme sports such as skateboarding, snowboarding, BMX riding, mountain biking and climbing with the small, tough GoPro camera that developed a new genre of point of view (POV) filmmaking. This is a new genre of filmmaking that has grown from being an amateur pastime into a mainstay of commercial filmmaking for the advertising and entertainment industries.

5. Behind the Scenes Film: This is an area of filmmaking that has been instigated by magazines and brands looking for content for their websites that gives their audiences an inside track on how their fashion, portrait and campaign images have been created. They are a great insight into how a professional photo shoot comes together, but they have a tendency to be formulaic in their construction.

As you can see from this list of moving image areas of practice, professional photographers working with the moving image are not creating scripted, storyboarded films featuring actors and actresses, the kind of film that you might see at your local multiplex. They are primarily creating films to be seen online, although two photographers have made documentary films over the last few years that have been Oscar nominated: Danfung Dennis' *To Hell and Back* and Tim Hetherington's *Restrepo*. A simple story, with basic editing skills and

Tips to Help You Create Good Audio

1. Use the best microphone or audio recording device you can (you can use your phone if that's the best you can access), and ensure that it is as close to the person speaking or the sound you want to record as possible.

2. Use extension leads to help you get your microphone close to your subject and off your camera. This will allow you to record good sound and get the composition of the shot you want.

3. Test how the room sounds before you start recording to check that it does not sound too 'boomy.' A large empty room will sound like this, while a well-furnished room with carpet will sound 'warm.' Decide before you start recording what kind of sound you want.

4. Record the 'silent' room for approximately three minutes before you start recording any interviews. You will need this in the edit to prevent 'drop outs' in the background sound. No room is ever truly silent; try listening to a silent room yourself to hear all of those minimal background sounds.

5. Use headphones when recording sound.

6. Start to build an audio library. There are all sorts of sounds you may want to utilize in a film that you hear as you live your life from day to day, so why not start recording them and keeping

them. I use a free app on my smart phone to do just that!
7. The term 'soundscape' refers to an audio soundtrack for your film that features sounds from different sources, including pre-recorded music.
8. If you want to use music in your film, ensure that you use non-copyrighted music from a library that provides this. There are many of these libraries to choose from, some of which you have to pay for and some you don't; it's up to you which you choose to use. Don't forget that musicians hold copyright on their music just as photographers hold the copyright of their images. Using your favorite piece of music by your favorite band or musician is theft and can be treated a such!

a good soundscape can result in a good piece of filmmaking, so why not give it a try. I think you will be surprised by just what you can achieve.

TIPS TO HELP YOU CREATE GOOD MOVING IMAGE

1. Use a tripod or a slider or rig to support your camera.
2. If you are using a tripod, use a fluid head to help you with your panning shots.
3. Check your white balance if you are shooting in a location with a mixture of light sources.
4. Always shoot more than you need, and leave a gap when the camera is running before your subject starts speaking and after he or she has finished. This will help you greatly in the edit.
5. Shoot 'A' roll and 'B' roll. 'A' roll is the main subject of your film, and 'B' roll is the material that you will use as 'cutaways': these could be details in a room, a view, the details of a subject such as hands, eyes and so on.
6. When shooting interviews, have your subject look just off camera to your left. This will make the interview seem less confrontational and give you interesting options with the composition of the frame.
7. Experiment with camera angles, depth of field and have fun!

WHAT CAN I DO WITH MY FILM NOW THAT IT'S FINISHED?

The process of creating a series of photographs or a piece of moving image can be hugely rewarding, but it can also be important to have a home and future plan for the work when it is completed.

Photographic projects can result in exhibitions, books and additions to your website, and short films can have a similar variety of different platforms on which they can be seen.

Photography is truth. The cinema is truth twenty-four times a second.

Filmmaker: Jean Luc Godard

I guarantee that if you enjoy your first filmmaking experience you will want to go on to make more. If this is the case you should look to place them onto your Vimeo page and start to build up a portfolio of films. This could be useful if you want or need to apply for a photographic or filmmaking-based course as part of your education pathway. I have interviewed a number of students who have shown me short films at interview, and I have always been impressed by their sense of creative adventure and offered the students a place on the course there and then.

You can and should put your very best films on your website under their own category on the homepage. This shows the importance of checking that whatever type of website you have is capable of hosting video content. Sometimes this is an additional cost option and sometimes it is free, so make sure you research this before tying yourself into any form of annual subscription.

If you believe that your films are good enough you could enter them for a competition. There are many of these: some accept general entries, some have specific themes, some have specific length requirements and others are directed at a specific age group. There are lots for young and student filmmakers, so you should have no problem in finding the right one for you and your work. Film competitions are often connected with film festivals, with an opportunity to show at the festivals as a prize associated with the competition. Look out for these, as they can give your work great exposure and

The Great Film Directors
Just as with the history of photography, the history of filmmaking is filled with great practitioners whose work it is essential that you look at for inspiration and understanding of the craft of filmmaking. Here are some you should check out:

Woody Allen
Martin Scorcese
Gus Van Sant
Robert Altman
Jean-Luc Godard
Alfred Hitchcock
Ridley Scott
Francis Ford Coppola
Ken Loach
Robert Redford
Clint Eastwood
D.A. Pennebaker
Steven Soderbergh
Jane Campion
Spike Lee
Wes Anderson
Kathryn Bigelow

the opportunity of seeing your film on the big screen! A word of warning, however: some competitions will expect you to pay for entry (this is the same with photography competitions, as I will discuss later in this book). Before doing this research the competition, find out how many entries they will expect, how long the competition has been running and how well respected it is by the film industry.

THE TWENTY-FIRST CENTURY PROFESSIONAL PHOTOGRAPHER

AS I HAVE ALREADY mentioned, if you are a student of photography today and less than twenty-five years of age you are often referred to as a 'digital native', someone who was born and raised within a digital world. This gives you a fantastic advantage over anyone born before the birth of the global digital revolution. Why? Because you do not need to relearn anything: you do not have to unlearn old ways of doing things, and you have been educated through digital technology. Yet the role of the professional photographer in the twenty-first century requires more than just digital awareness. That's why I decided to start this chapter with a quotation by one of the greatest photographers of the last century, who famously worked with only one type of camera, the one a photographer would start working with in the 1930s.

> *Your first 10,000 photographs are your worst.*
> Photographer: Henri Cartier-Bresson

> *Be daring, be different, be impractical, be anything*
> *that will assert integrity of purpose and imaginative*
> *vision against the play-it-safers, the creatures of the*
> *commonplace, the slaves of the ordinary.*
> Photographer: Peter Lindbergh

The professional photographer today has to have that digital awareness and willingness to embrace new technologies, but they also have to have an understanding and awareness of what has come before. The history of photography is rich with stories, experiences and images, all of which inform the images that are being created today and those that will be created tomorrow. Whatever you do, make sure that you immerse yourself in that history and enjoy exploring work that can help you develop your own visual language. As a professional photographer you are going to be expected to know about the great photographers of the past as well as the photographers working in your area of specialization today, so make sure you

know your stuff—you don't want to get caught out! Imagine if you were an artist but had never heard of Pablo Picasso or Leonardo da Vinci, you wouldn't be taking your art seriously; so make sure you know about Cartier-Bresson, Penn, Avedon, Brandt, Sander and Capa, among so many others, as well as those working today.

A lot of photographers think that if they buy a better camera they'll be able to take better photographs. A better camera won't do a thing for you if you don't have anything in your head or in your heart.
Photographer: Arnold Newman

It is understanding the past that will help you make the most of the present. Don't look at it as boring theory, nonrelevant history or tedious college tasks, because it's none of these things—it's the foundation for your future career. While teaching a group of photography students, I asked them to share with the group their favorite short films and movie trailers. A few chose films that were trailers for genre films: horror films and gangster movies set in the 1920s and 1930s. I showed them trailers for films that were made during the period that their films were looking back to and emulating. The films I showed were in graphic black and white, with strong lighting and what would today be described as 'wooden' acting. The general feeling was that these films were boring because they were in black and white and that the lighting looked 'fake.' None of the students said that they would go to see a black and white film.

A few weeks later when the same group of students showed the films they had made, a number of them were in black and white. In the process of creating their films they had begun to understand why the films I had shown them 'worked.' They had become used to seeing in color as a result of what they see on a daily basis, but it was only by engaging in the visual creative process of creating a narrative that they started to understand the power of black and white images. The

past started to make sense to them and inform their work. Be open to all influences from all areas of creativity, including film, dance, art, sculpture, music, writing among everything else, and never be too negative without understanding why you are being negative.

A negative approach to your own and others' photography can only be subjective if it is formed without understanding and a willingness to listen to others and work as a team. Never before has photography been so reliant on the ability to collaborate. But before I speak about that I just want to explore this negative subjectivity when expressing opinions about photography.

> *A positive attitude can really make dreams come true—it did for me.*
> Photographer: David Bailey

I LIKE IT, WHY DON'T YOU?

One of the most difficult aspects of changing photography is that any comment that is made is subjective: it is somebody's opinion that you may or may not agree with. This instantly provides a problem for you as a student if someone criticizes your work, but you either don't agree with him or her or understand what he or she is saying. The same situation applies when you are dealing with a client. If you find yourself in this situation then here is some advice to deal with it when it happens, and perhaps prevent it from happening at all. The solution is to remove the subjective and become objective, and to do this you need to understand the context of why the photograph was taken. This then allows you to comment on a photograph as being either successful or unsuccessful in its intent. If your argument for a picture being successful is because you 'like' it, you will always be open to others saying that they don't. That's okay, but

it means that neither of you can move the conversation forward, without understanding that there can be no informed discussion on that basis.

UNDERSTANDING CONTEXT

If I take a photograph of a loaf of bread, no matter how beautiful the image may be, how technically and aesthetically perfect it is, as a fashion photograph it is unsuccessful. As an image for a magazine article about making bread it is successful. It doesn't matter if I like it or not, the reason why it was taken and the place in which it is going to appear provide the context for the image. Therefore, objectively, you will know and the client or your lecturer will know if it is successful for its intended context.

Once I have decided if the image is successful for its initial context, the second decision as to whether or not the image is successful is based on an aesthetic and technical context. This context is set by the work created by other photographers shooting a similar subject from a similar level of experience.

If a photograph of a loaf of bread for example fulfills the aesthetic, narrative and technical requirements that other images featured in a magazine demonstrate, then it is appropriate for its context. It is therefore a successful image. If it is not, then it is unsuccessful. These judgments have to be completely objective; as the photographer, these decisions cannot be made from an emotional perspective. You can't allow the time, money or effort you have committed to creating an image or series of images to make you believe that an unsuccessful image is better than it is. Within professional photography the image either works or it does not work, and the client will tell you quickly if it is the latter! To avoid this happening, learn to talk about and explain your work to understand which of your images are successful and unsuccessful. This understanding will then be

essential for you to take to all of your shoots to ensure that you are taking images that you will be able to discuss and possibly defend.

Even if you are really good at discussing your work, you will always disagree with people about specific images. Never take criticism personally, don't be afraid of passionate debate and always listen to other people's opinions based on their experience and knowledge. All of this is part of the creative learning process, and as long as you understand the context of your images and your intention in taking them, you should always feel confident in your photography.

Photography offers all the things a young person desires—a sense of purpose, a real sense of adventure and something at the end of it to reward you.
Photographer: Donovan Wylie

SHOOT MORE!

The most common mistake that student photographers make is in not shooting enough. By that I mean not only not enough shoots, but also not enough frames on a shoot. In the days of analogue film photography this was understandable, as every time the shutter was pressed a cost was incurred with film, processing and printing— all expensive aspects of photography at the time. But today digital capture allows you to shoot as much as you want and as often as you want for free!

This is important for you as a student, as it is only by shooting that you are going to learn about photography. Although I believe greatly in the importance of looking at other photographers' work, it is only by taking your own photographs that the lessons become real. It is

also important from a client's perspective when commissioning a photographer. There is little doubt that at some point in your photographic career you are going to have a client ask you to give him or her 'choices,' but what does this mean?

I have spoken repeatedly about the world of professional photography being a business, an industry, and the people who commission are just as much a part of the business as the photographers. This means that their jobs are as reliant on you taking successful pictures as yours is. It's essential you understand this and show empathy for their position when accepting a commission. They will not want to be presented with one image from a shoot or even two or three; as I have previously mentioned they will expect a selection of images. That selection of images will need to contain a number of successful images for them to choose from, and to achieve this you will need to shoot a lot, especially when you are starting out and still learning your craft.

You will only get one opportunity to shoot whoever or whatever you are shooting, so make sure that you 'cover the story' from every angle, and never put yourself in the position of having to tell a client that you didn't try something because you didn't think it worked. Shoot everything so that you can show them it didn't work and explain why.

Don't be afraid of shooting, and never think that you are going to get the shot in two or three frames. I have been working as a professional photographer for fifteen years now, and I always shoot and shoot around a subject to make sure I get what I and the client need. I have no problem with this, and neither should you.

DO I HAVE TO MOVE TO A BIG CITY TO BE A PROFESSIONAL PHOTOGRAPHER?

There is a long-held myth about professional photography that to be a success you have to live in a big city. For a long time this was true, but not anymore—or at least not anymore unless you want to be a fashion photographer. Let's deal with everything except fashion photography first.

The moment you build a website and place your work on it you have a global audience, and the same applies for your social media presence and any other platforms you use online. This instantly means that you have a potential global marketplace as well as a national and regional one. This is important to understand, as you are just as likely to be commissioned by a client in another country as you are from one in your hometown. How does this work? Well, for example, if a magazine in France wants to photograph an author who lives near where you live, they are not going to send a photographer from France; they are going to look for someone local to the author, wherever that author lives. That photographer may be you, and if you do a good job you then become someone they know in a country that they may shoot in regularly, so a client relationship begins and subsequent shoots can follow. International relationships can be easy to progress and establish today, thanks to free email, Skype and image transfer platforms. So think global! You never know where your next client could come from.

As a professional photographer you must be prepared to go wherever the client wants you to go to fulfill the commission. Despite being a UK-based photographer I have been commissioned to shoot across the world, from the North Pole to Pakistan, from Italy to New York. Perhaps the strangest commission was when a client in San Francisco asked me to fly from the United Kingdom to São Paulo, Brazil, to shoot a story for them; they particularly wanted me to shoot the story and were willing to pay for this to happen. It is a moment

like this that makes you realize just how incredible a life your photography can give you.

So your work can be seen online and you can be contacted by clients you have never met. You can also be a photographer working in an area where few other photographers live and that you can cover. This can work well for interiors, portrait, sports and documentary-based photographers, but fashion photography still requires you to be where the best models, clothes, studios, stylists and hair and make-up artists are, and in most cases this means being based in a major city.

If you want to work as a fashion photographer for national and international magazines and clients, you are going to need to be where the action is. If you want to photograph surfers you will follow the surf, and it's the same with fashion. In fashion, London, New York, Milan and Paris are the locations you will need to consider as part of your future career. Of course, you may be happy working for local or regionally-based fashion clients, and that's great if it works for you. It all comes down to expectations, so be sure you understand what you want and what is required to achieve it.

CREATE NARRATIVE AND BE CONSISTENT

The creative opportunities available to the professional photographer today are not new. Photographers such as Paul Strand and Man Ray were making films in the 1920s; photographer Bert Stern made the classic *Jazz on a Summer's Day* in the 1950s; David Bailey and Brian Duffy made films in the 1960s; while photographer Gordon Parks made *Shaft* in the 1970s. These are just a few notable examples of photographers drawn to the moving image, and there are many more.

Photographers have always been happy to talk about their work for television and radio interviews and to share their work through

exhibitions and festivals. None of this is new to the digital age, but the big difference today is that anyone can now do all of this easily, and most importantly cheaply. Creating images today is democratic: anybody can do it, and nearly everybody does!

So where does that leave the professional photographer? When anyone can take a good photograph? Well, to me the answer is simple: as a professional photographer the two things that you need to demonstrate that you can do are create narrative (to be able to create a series of images of equal strength that introduce, develop and deliver a visual story based upon your photographic subject matter) and be consistent (every time you shoot, whether on a self-initiated or commissioned basis, you create compelling images based upon your personal visual language).

EXPENSIVE CAMERAS DON'T MAKE GREAT PHOTOGRAPHS

It doesn't matter what you use to create narrative and be consistent as long as you can do them. It is important to have the right equipment to do the job you need to do, but the equipment alone is not enough. It never has been, and it never will be. You are the secret weapon behind the camera.

This was clearly proved when Hurricane Sandy hit New York a few years ago. This was when Instagram's status among professional photojournalists changed dramatically, thanks to a decision made by *TIME* Magazine in late October 2012. With Hurricane Sandy fast approaching the Eastern seaboard, *TIME* Magazine's director of photography, Kira Pollack, rounded up five photographers and gave them access to the magazine's Instagram feed. He chose professional photographers Michael Christopher Brown, Benjamin Lowy, Ed Kashi, Andrew Quilty and Stephen Wilkes, all of whom were established and consistent users of Instagram, to take news

images with their smart phones to be used online and document the devastation the hurricane caused.

Pollack wanted to ensure that he had the fastest and most direct route to cover whatever events unfolded and get images to his readers. Instagram seemed to be the obvious answer, and the fact that the chosen photographers would be covering those events with their smart phones and not professional cameras was not an issue. The resulting portfolio of images was posted on *TIME*'s photography blog, and was responsible for 13 percent of all the site's traffic during a week when Time.com had its fourth-biggest day since its inception. The magazine's Instagram account attracted 12,000 new followers during a forty-eight-hour period. Pollack's brave and creative decision had been validated, and serious photojournalism had been created using camera phones. The very equipment and platforms that had been adopted by the 'citizen journalist' had been accepted by the world of professional photography.

This is a great example not only of how the world of professional photography is changing but also of the importance for professional photographers and clients adopting new ways of taking photographs and sharing them with their potential audience.

When students begin the course I lecture on, we suggest that none of them buy what is considered to be a high-end or professional camera, but we do suggest that they have a smart phone on them at all times to record lectures, take pictures during lectures, Tweet from lectures and document what they see as they live their lives. It is this combination of creative tasks that defines the essential skill set of the twenty-first century photographer.

Nothing happens when you sit at home. I always make it a point to carry a camera with me at all times ... I just shoot at what interests me at that moment.

Photographer: Elliott Erwitt

Photo Sketch with an iPhone

A smart or Android phone is not a true professional photographer's piece of kit, but many professional photographers use them to 'photo sketch,' creating images in a loose, experimental style. This is a great way to keep yourself taking pictures, developing your visual language and expanding your ability to build narratives. Here are a few places for you to check out to keep you inspired and to see just what's possible with the tiny camera in your pocket.

1. *FLTR* is the world's first smart phone photography magazine, published weekly and designed exclusively for the iPhone. It was created by the team behind the *British Journal of Photography*, the world's longest-running photography magazine.
2. The AMPt Community is a network of mobile phone photographers, artists and filmmakers. Their website AMPt includes user profiles, photo and video uploading, chat, blogs, a forum, photo challenges, featured artists and more.
3. EyeEm is primarily known as a photo-sharing app, but they also have an interesting mobile photography blog where they run photography challenges, feature talented photographers and share mobile photography tips.
4. Grryo is a mobile photography website with a goal to promote and support

IT'S NOT ENOUGH TO JUST TAKE PICTURES!

mobile photographers. Their website contains articles, tutorials, reviews and interviews that have been published by members of the community.

5. Instagrammers is a global community of Instagram users and mobile photographers. In addition to Instagram, their website covers mobile photography apps, tutorials and other relevant news.

6. iPhoneography Central features regular app reviews, tutorials, artist features, kit reviews and more and is one of the world's leading iPhone photography websites.

7. *iPhoneography Today* is a curated online newspaper by iPhoneography expert and professional photographer Jack Hollingsworth, who features everything that's going on in iPhone photography.

8. The App Whisperer is a large and energetic iPhone photography website. Their primary focus is app-related news, but they also publish interviews, tutorials, industry news, competitions and a lot more. They have many talented columnists, including many award-winning iPhoneographers.

It is no longer enough to just take photographs as a photographer. You will need to be able to market your work, speak about it, present it, sell it, create moving images, record audio, edit your work, edit moving images, build a website, design marketing material, hang exhibitions, network, self-publish, design books and post-produce your images. Now before you panic, you don't have to do all of these things to a highly specialized level of skill, but you do need to have a basic understanding of most of them, and the better you are at networking, speaking about your work and marketing your work, the better chance you will have in progressing your work creatively and commercially. Speaking to people about your work is an essential process of professional photography, and it is a skill you need to master as soon as you can. A great way of learning how to do this is to listen to others speaking about their work and about photography. Listening to photography podcasts allows you to do this wherever you live and at whatever time you have to spare. I've recorded a few in my time, and they are fun and easy to do, so if you like the idea of creating your own have a go. Either way, I have put a list together of a few to get you started listening.

WHAT DO YOU EXPECT?

I have spoken about the client's expectation of the professional photographer and how this is constantly evolving as the client becomes more and more aware of the creative opportunities new technology brings, but what is your expectation of a career as a professional photographer? I'm sure it's changed since you started reading this book, but what is your expectation now?

My intention up until now has been to give you the information you need to make the right decisions for you and your photography, the kind of information that is not necessarily easy to find. But now you

have it, and where you want to go and how you want to get there is completely in your own hands. A career as a professional photographer is open to anyone who is willing to work really hard and make the commitment and sacrifices that have to be made, but the rewards are there for you if you are willing to do this.

How hard you are willing to work, for how long and for how much financial return are all very personal decisions you will have to make, and as photography has no set salaries, career progression or structure, it will be you who sets your own career agenda. Of course, this has always been the case, but today that agenda can be set with very little immediate financial outlay or ongoing expenditure. This is why today's photographic environment is so exciting—anything is possible.

PICK UP THE PHONE!

I've spoken about the importance of your online presence and the advantages you have with your understanding of digital communication, but both can have a very negative impact when it comes to beginning your career.

Professional photography is a people business: people buy people, and they have to like your work to work with you, but they also have to like you and consider you to be a good ambassador for their brand, magazine or company. To do this you have to have good social skills: you need to understand how to act in a variety of different situations, and how to be confident in yourself and your work and never be arrogant.

These skills are essential for you to develop for when you meet clients and when you are on a shoot, but neither of these things are going to happen if you can't demonstrate them when making an initial contact. This contact today is going to be made via email and

Photo Podcasts to Check Out

All of these are free to listen to and available via iTunes or from the podcaster's website. Choosing a podcast to follow is based completely on personal taste, so try a few and see which ones work best for you. If you don't like my choices, there are many more for you to choose from on iTunes.

1. German-based Chris Marquardt's *Tips from the Top Floor* is the longest-running photography podcast to date, and it's often funny and always honest: www.chrismarquardt.com.
2. Jeff Curto is a photography professor at the College of DuPage near Chicago who records his class lectures about the history of photography and presents them in his *History of Photography* podcasts. Available on iTunes.
3. *The Art of Photography* is a weekly podcast presented by Ted Forbes, the manager for multi-media at the Dallas Museum of Art. He covers everything from composition to technique and profiles renowned photographers. Available on iTunes.
4. Jeffery Saddoris and Bill Wadman present *On Taking Pictures*. Saddoris is a New Media artist who worked for Universal Pictures. Wadman is a portrait photographer based in New York who has had his work featured

in *TIME* Magazine and *The New Yorker*, among others. They give personal and detailed advice for newcomers and experts. Available on iTunes.

5. Frederick Van Johnson's *This Week in Photo* deals with issues such as plagiarism and the future of photography, as well as giving photography tips and tech tutorials: www.frederickvan.com.

6. Scott Bourne and Richard Harrington's podcast *photofocus* features pro photographers and gives an opportunity for listeners to ask questions on the show, which is recorded three times a month. Available on iTunes.

telephone: you have to do both, and there is an order to follow that I recommend to all students when making a 'cold call,' or contacting someone you don't know. This is it.

1. Telephone the person you want to show your work to directly. Find out his or her name and job title before ringing.

2. When you get through to the person introduce yourself as a young photographer who is looking for advice and feedback on your work.

3. Expect the person to suggest that you send a link to your website in an email.

4. Accept this and be polite and send the email directly after the conversation has finished. Title the email "As Requested In Our Conversation."

5. Ensure that you make the link a 'hot link' so that one click takes someone directly to your site.

6. A few days later make a follow-up telephone call re-introducing yourself and asking if they have had a chance to look at your site. If they do not want to speak to you or are noncommunicative about your work you should accept that they are not interested in you and yet again be polite, thank them for their time and move on. If they are positive, then ask if you could meet them in person at a time that suits them. Accept whatever time and day they suggest, whatever your situation—it may be your only chance!

7. Whatever the response you have received, post the person you have spoken to some postcards featuring your work as a reminder of who you are and what you do.

Of course, all of this relies upon the ability to make a phone call, and in a world in which you have become reliant on email, instant messaging and texting, the idea of doing this can bring fear into many students' hearts. I know of many students who have been reduced

to tears just by the idea of making a simple phone call to a potential client; they have been so fearful of making a phone call that some have failed course modules that require this interaction with the industry. It's easy for me to say there is nothing to fear, as I have had to speak to people on the phone throughout my career, but whether you find it easy or not you will have to do it. So here are a few tips to help you conquer this fear if you have it.

1. **Practice by phoning adult family members and asking them the questions I have outlined above. Make sure that you explain the reason for needing to do this before you call, and ask different family members to respond in different ways. Some should be patient, some friendly, others short-tempered and maybe disinterested. These are all responses that you may come across and will have to deal with.**
2. **Always make phone calls from a landline in a quiet room when you are relaxed.**
3. **Make a list of the things you want to say in easy-to-read handwriting on an A4 piece of paper before you make the call.**
4. **Have your diary for the coming weeks open in front of you so that you can book in a meeting if one is needed.**
5. **There really is no way forward if you cannot master the art of making a business phone call, so please don't hesitate in taking your first steps.**

HOW TO SEND AN EMAIL

I know that most of you will have sent many emails and probably think that you know what to do and how to write one, but how many of you have had to write a business email? I have received so many poorly written and inappropriate emails from students and young photographers that I would guess that not many of you have any experience

of this form of initial communication, so I have put together a guide for you to follow every time you send one.

1. Choose a subject heading that is succinct and accurate for the content of the email you are sending, and change the subject title if the content changes within an email trail. This allows the client and you to track back and find an email you are looking for quickly and easily. Never use the subject title "Hi."

2. Always address the email to the person you are sending it to, especially if you are emailing someone for the first time. Always use "Dear X," never "Hi."

3. If you are sending a group email to announce an exhibition or book launch event, for example, always use Bcc (blind carbon copy) to ensure that the receiver cannot see everyone else you have invited.

4. If you include a link to your website ensure that it is a 'hot link.' A potential client cannot be bothered to cut and paste your URL.

5. When sending large image files, use a sending package platform such as WeTransfer. Never send consecutive emails with each containing a large file. If you are attaching files to an email, always check that you have actually attached them before you press Send.

6. Many companies set a limit on their staff's email inbox capacities, so do not fill these up with large HTML emails or attachments.

7. Be aware of company firewalls. Many companies have firewalls to prevent spam and viruses breaching their security systems. These can block HTML emails, attachments and emails containing certain key words. Following up an email with a phone call can detect if your email was blocked and if it needs to be re-sent in a different format.

8. Check your spelling and grammar. Then check it again before clicking Send.

9. If you are sending an email promoting your work to people you do not know, send it at these specific times to give it more chance of being seen: Monday to Friday between 11:00 a.m. and 12:00 a.m. but never on a Friday afternoon or a Monday morning. These are the times when clients will be hoping to go home for the weekend or deleting all of the junk emails they have received over the weekend. Also avoid sending during lunch times, early morning or late in the afternoon. These are usually times when people are not at their desks, and therefore the times when inboxes fill up. A full inbox is often too quickly emptied of emails from unknown senders.

10. Do not become an email-sending stalker. Balance how many emails you send and how often. If you don't get a response, make a phone call. If they don't want to speak with you, accept that it's time to accept defeat.

CAN I SHOOT FILM AND GET COMMISSIONED?

The popularity of filters and effects on smart phones, tablets and via photography apps based on traditional photography has in turned inspired and encouraged a lot of young photographers to consider analogue photography. Believe me, I understand the attraction: I grew up with and began my career as an analogue photographer. I appreciate the process, the magic and the end result of a beautiful print. However, we are talking about the world of professional photography here, not just photography, so it is important to understand the role that analogue plays in a commercial digital world.

Fortunately, that role is pretty easily defined. On a commissioned basis, don't expect to have clients pay for your film or processing, or to be happy for you to shoot analogue. Many established photographers, such as Steve Pyke, Bruce Weber and Peter Lindbergh, still shoot this way, but you are just starting out, and your clients are not

going to have the confidence in you that they would have in them. They may well want to be on the shoot and have input into how the images look; they have become used to doing this, thanks to digital technology, and this is a hurdle you may not be able to overcome.

If they are happy for you to shoot analogue, and you are happy to meet all of the costs incurred that they will not meet, they are still going to want you to supply them with a high-quality digital file created from your negative or transparency. That's an additional cost that you are also going to have to meet. Unfortunately, today's budgets are based on a digital world and not an analogue one.

The digital world also has a tendency to want everything now! Analogue requires time and specialists, neither of which the clients are willing to take into account. In reality, then, analogue is a very uneasy fit with today's commercial expectations.

However, if you want to create work outside of the commissioned environment, there is no reason why you shouldn't explore analogue and alternative processes such as cyanotypes, pinhole or tintypes among many other ways of creating a photographic image. Of course, if you wish to place the work online or have it published, you will need to create a digital file of some sort. If this is the way you want to work, my only suggestion is that you don't ignore digital photography. When you start out, the most important thing is that you are taking pictures every day. Too many times I have spoken to students who have lost images because their analogue technical skills were not up to scratch, or they were not able to afford to buy film or get film processed. You may be lucky in that your college or school has a digital scanner, but if not you can expect to pay upwards of $25 for just one digital scan.

The romance of analogue photography is not to be ignored, but consider this: a vinyl record is a thing of audio beauty, but can it be downloaded? Of course not. The information it contains now has new ways of being distributed and consumed that you find easy and

appropriate for the way you live your life. Now look at an analogue photographic print in the same way, and you'll see why it is no longer appropriate for the clients you are hoping to work for.

I LOVE PHOTOGRAPHY BUT I DON'T WANT TO BE A PHOTOGRAPHER!

When you start studying a subject like photography at school or at college (or maybe when you started reading this book!) your knowledge and experience of the world of photography as a career is usually pretty limited. In some ways this is not your fault, although I would argue that it has never been easier to do the research to get some idea of what will be expected of you. Either way, you are either at the beginning, well into or just finishing your photographic education, and you may be starting to think that the role of the professional photographer is not for you. If this is the case, don't panic!

The world of professional photography has many full-time roles within it for people who love photography but don't want to be a photographer. Here are just a few, with brief descriptions of what is involved in each role:

1. **Picture/Photo Editor: Commissioning photography for magazines and newspapers, researching images and sourcing images from stock libraries. You may also be involved in arranging shoots, overseeing budgets and sourcing props.**
2. **Retoucher: Post-producing images for photographers, either on a freelance basis or within an existing post-production company.**
3. **Stylist: Sourcing clothes and props for shoots and developing creative ideas for shoots with photographers and clients.**

4. **Agent:** Representing photographers for commercial work, marketing them to potential clients and overseeing budgets and all details concerning shoots and payment. You would start out working within an existing agency but may progress to establishing your own agency.

5. **Curator:** Developing and creating exhibitions of photographers' work.

6. **Location Finder:** Finding locations for stills and moving image shoots. You would start out working within an existing agency but may progress to establishing your own agency.

7. **Production Assistant:** Organizing all of the details for a photographic shoot, including locations, models, props and so on.

8. **Art Buyer:** Commissioning photography for advertising campaigns, researching images and sourcing images from stock libraries for clients.

9. **Teacher/Lecturer:** You will need to continue your photographic education and add a teaching qualification to teach, but there is no reason why you can't consider this as an option.

All of these roles will involve a large number of the skills you will have learnt as part of your photographic education (these are often referred to as 'transferable skills'). So if you like the sound of some of these options, don't give up on your photographic education as it will be more relevant than you may think. These skills include the ability to talk about photography, understand photographic images, discuss the history of photography, know what equipment is needed and most importantly how to speak to and work with photographers.

The roles I have mentioned are just a starting point, and there are many variations on these that I have not mentioned. Suffice to say that a photographic education need not just be about turning you into a photographer.

I'VE READ THE BOOK, SO WHAT DO I DO NOW?

Throughout this book I have wanted to introduce you to the reality of the role of a professional photographer in the twenty-first century, while always remaining positive about the options and opportunities open to you. Everything I have said has been about giving you a starting point for your career and your understanding of photography as a business. I hope by now you have some idea as to where you might fit and how you can both progress your work and develop your progress through photographic education towards a rewarding career. That's my hope, anyway—only you know if the advice has worked for you!

I do know that you now have the information you need to start making some informed decisions about your work, but how you choose to implement this information is up to you, and this is the basis of working as a professional photographer. The choices you make are up to you. There is no structured career progression or single road to follow, and that is what makes it so exciting and rewarding. You can set your own agenda and create a working practice based on your own skills, interests and situations.

To help you do this I have suggested you explore a series of photographic briefs, but what do you do once you have done them? Well, you keep doing them again and again for as long as you enjoy responding to them and find them advantageous to your learning. The briefs I have set can be evolved, developed and expanded upon however you wish. They are templates for you to have fun with, but they are also all based on exactly the type of commission briefs you will receive throughout your careers.

These briefs are not just college projects set for you to either pass or fail, they are the basis of a professional photographer's working practice. If you've attempted some of the briefs and enjoyed them, that's a great sign. If you've tried one or two and not enjoyed them, have a look at attempting another that takes you into a different area

of photography and experimentation. If you haven't attempted any or enjoyed any that you have attempted, then you should seriously think about whether or not you really want to be a professional photographer or work within professional photography. That may sound like a tough piece of advice, but to be a successful photographer takes a huge amount of passion, commitment and the ability to take advice.

Professional photography is not a profession for the faint-hearted or for the arrogant, but it is one for the creative, the inquisitive and the open-minded. If you feel you fit that second description, then I wish you luck, success and creative fulfillment in your future career.

There are a lot of words in this book and a lot of advice, but before I sign off I'd like to leave you with four of the most important ones, LOOK, LISTEN, LEARN and DO!

Good luck!

A BRIEF GLOSSARY OF PROFESSIONAL PHOTOGRAPHY TERMS

Assistant:	A photographer's assistant.
Agent:	Photographer's representative.
Book:	Another term for a photographer's portfolio.
Budget:	The amount the client has to spend on a photo shoot.
Call sheet:	Details for a shoot; when, where and who will be on the shoot with contact details.
CMS:	Website content management system.
Commission:	The request to take photographs for a client.
Copyright:	The photographer's rights to ownership of the image.
Digi-Op:	A digital assistant on a shoot.
DPS (Double-Page Spread):	An editorial term used to describe a photograph used over two pages.
Drop off:	A request to leave your portfolio with a client.
Editing:	Choosing the right images.
Fee:	The amount you will receive for taking photographs.
Full-Page Bleed:	An image that fills an entire page. Bleed is the allowance for trim and should always be a minimum of 5mm.
Invoice:	The document you will send requesting payment.
Layout:	The term used to describe magazine pages.
License to use:	The agreement between the photographer and client.
Pitch:	Producing work for a client unpaid to attempt to secure a commission.
Post-production:	Retouching of photographs.
Pre-production:	Arrangements made before the shoot
RAW:	Raw files are digital files from your camera that have not been processed and therefore are not ready to be printed or edited.
Stock:	The selling of photographic images by an agreed-upon agency.
Syndication:	The selling of photographic stories by an agreed-upon agency.
Tethered:	Working with your camera connected to a computer screen.

RESOURCES

INSPIRATIONAL WEBSITES

There are so many places for you to go online to seek inspiration and information that it would be impossible for me to list them all. However, here are some of my favorites that should act as a good starting point for your online research.

www.littlebrownmushroom.com
www.thedailychessum.com
www.smalltowninertia.co.uk
www.theselby.com
www.photobookclub.org
www.showmepictures.co.uk
www.aphotoeditor.com
www.americansuburbx.com
www.unitednationsofphotography.com
www.flakphoto.com
www.scottkelby.com
www.strobist.blogspot.co.uk
www.source.ie
www.thesartorialist.com
www.facehunter.org
www.runway.blogs.nytimes.com
www.foto8.com
www.worldpressphoto.org
www.lens.blogs.nytimes.com
www.blog.magnumphotos.com
www.photojournalismlinks.com
www.bagnewsnotes.com
www.newsshooter.com
www.showstudio.com
www.testmag.co.uk
www.burnmagazine.org
www.theindependentphotobook.blogspot.co.uk
www.magculture.com
www.indiephotobooklibrary.org

CONTRIBUTORS' WEBSITES

www.emmaboyns.co.uk

www.venislavpetrov.com

www.emmafrancesca.com

www.jessclark.eu

www.charlottestevens.co.uk

www.benbreading.co.uk

www.liamclarke.co.uk

www.catherinewalterphotography.co.uk

www.tomhillphoto.com

www.kasiafiszer.com

www.louiseboynephoto.co.uk

www.jenrich.co.uk

ACKNOWLEDGEMENTS

Thank you to my students and colleagues at the University of Gloucestershire, with special mention for their support and patience to Nick Sargeant, Angus Pryor, Trudie Ballantyne, Dr. Sharon Harper and Matthew Murray.

A special thank you to the young photographers who kindly allowed me to use their work to illustrate this book, all of whom have recently studied in the Editorial and Advertising Photography Course at the University of Gloucestershire on which I teach: Ben Breading, Beth Dooner, Liam Clarke, Kasia Fiszer, Emma Woodcock, Tom Hill, Emma Boyns, Charlotte Stevens, Abbie Stewart, Jo Hodson, Robert Gifford, Tash Parsons, Jen Rich, Catherine Walters, Veni Petrov, Jess Clark, Courtney Brock, Louise Boyne, Ryan Fife, Abi Whiddett, Flynn Hunter and Pat Feeney.

Finally, a thank you to my editors at Focal Press, Kimberley Duncan-Mooney and Anna Valutkevich.

INDEX

Note: Page numbers in *italic* refer to illustrations.